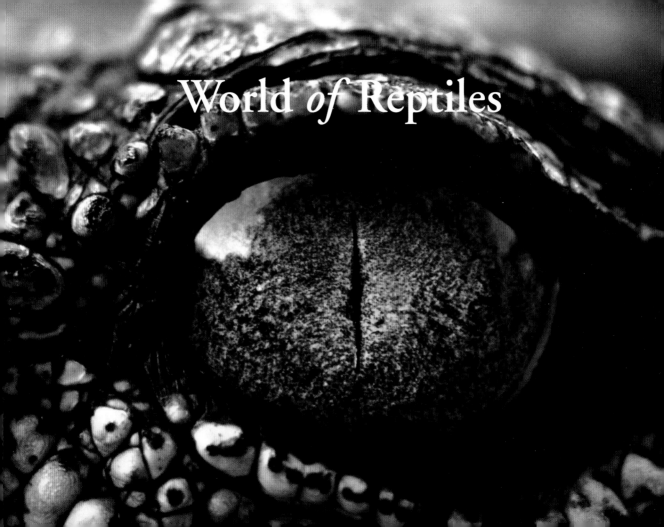

World *of* Reptiles

World *of*

Reptiles

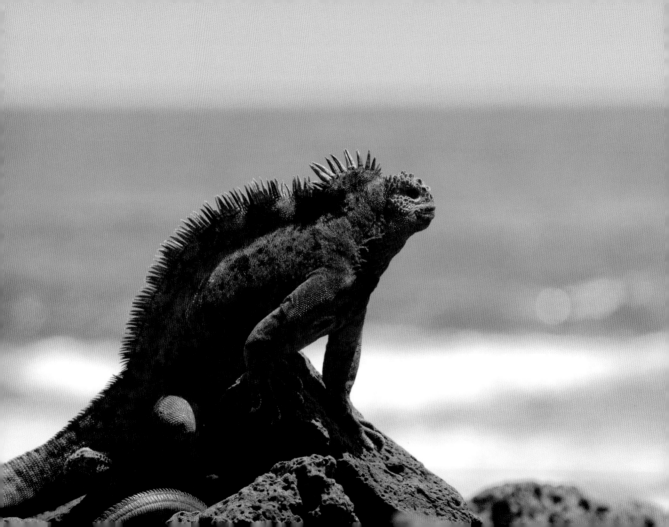

Introducing the World of Reptiles

Venomous snakes and deadly crocodiles tend to be the reptiles which capture the imagination of most people, but the diversity of the planet's reptiles is so much greater than this, with many of the smaller and less well-known species being of equal or greater interest than their famous relatives.

World of Reptiles is a visual celebration of the planet's varied and amazing reptilian life. At present there are estimated to be around 10,800 reptile species from 86 families – from oceanic Leatherback Turtles to subterranean Blind Snakes – utilising almost every habitat available.

The book contains 240 images covering more than 220 species from 68 of these families, in order to depict as wide a diversity as possible of reptiles worldwide. The pictures have been selected in order to show the varied nature of reptile forms, encompassing Turtles, Tuataras, Lizards, Snakes, Amphisbaenians and Crocodiles, and the range of interesting things they do, such as hunting, hiding, feeding, displaying, hatching and much more. In some cases they show the reptiles in the context of the landscape of their natural habitat, while in others they depict a very rare species or family that may rarely, if ever, have been included in a book before.

Estimates of the exact number of reptile species vary according to the latest studies, and are changing all the time as we learn more, but for the sake of giving some order to the images *World of Reptiles* has adopted taxonomy and nomenclature recommended by The Reptile Database (www.reptile-database.org) as the basis for the listing.

Above all, we hope that you enjoy this book and its amazing images, and that it contributes towards inspiring further interest in reptiles and their conservation worldwide.

TURTLES

Alligator Snapping Turtle *Macrochelys temminckii*
USA

Common Snapping Turtle *Chelydra serpentina*
NORTH AMERICA

European Pond Turtle *Emys orbicularis*
EURASIA

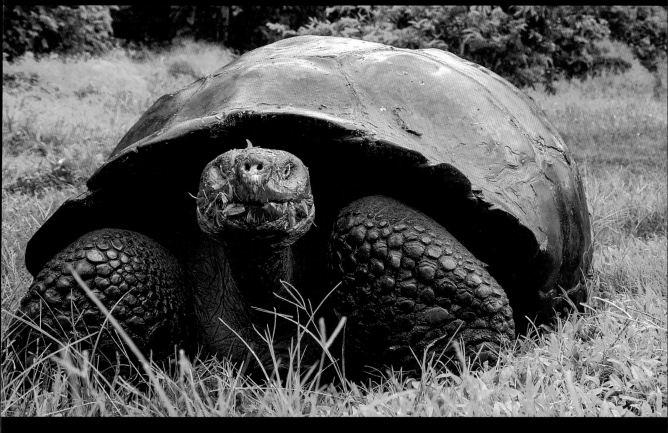

Galápagos Tortoise *Chelonoidis nigra*
GALÁPAGOS ISLANDS

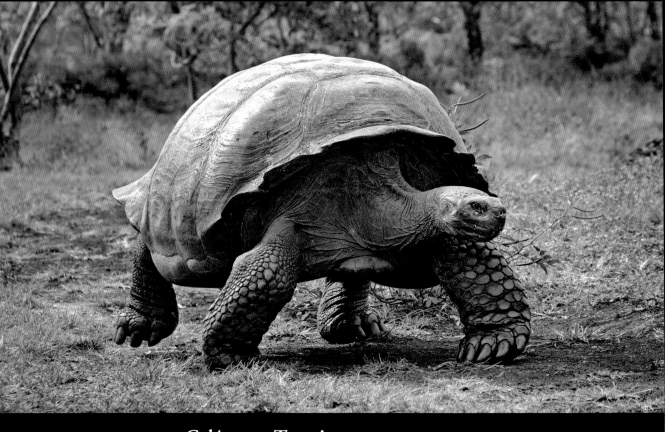

Galápagos Tortoise *Chelonoidis nigra*
GALÁPAGOS ISLANDS

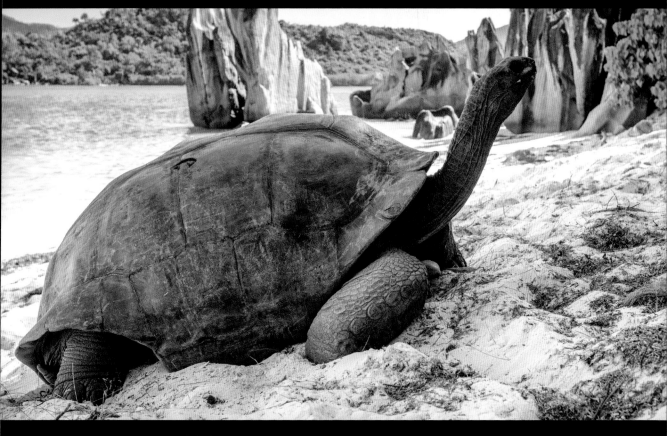

Aldabra Giant Tortoise *Aldabrachelys gigantean*

SEYCHELLES

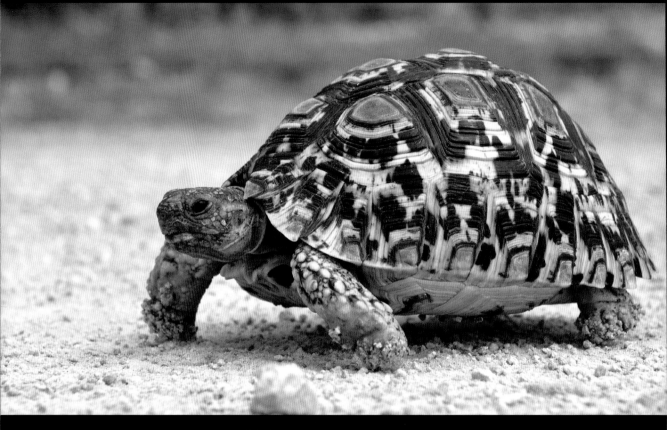

Leopard Tortoise *Stigmochelys pardalis*
AFRICA

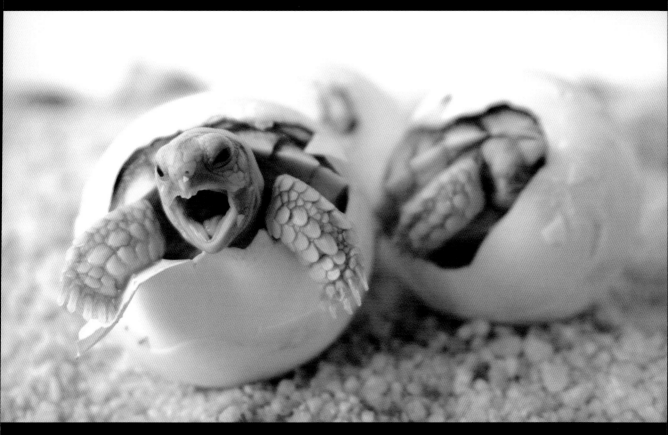

African Spurred Tortoise *Geochelone sulcata*
AFRICA

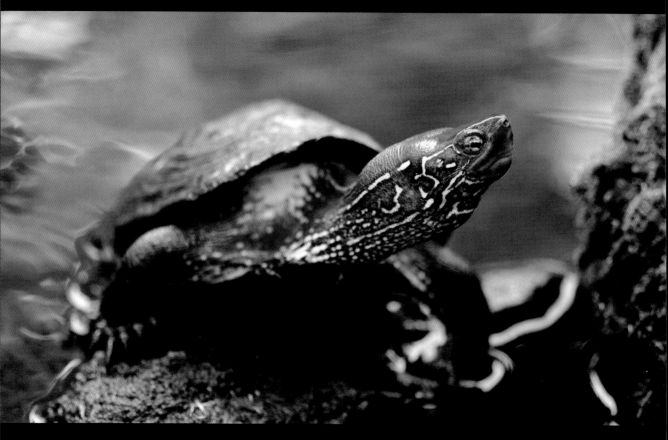

Reeves' Turtle *Mauremys reevesii*

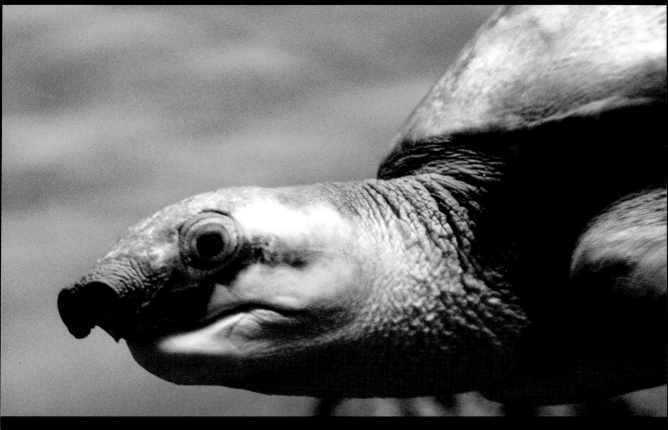

Pig-nosed Turtle *Carettochelys insculpta*

AUSTRALIA AND NEW GUINEA

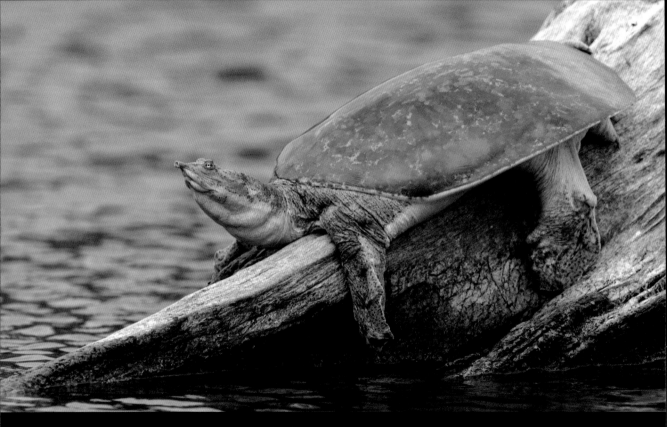

Texas Spiny Softshell Turtle *Apalone spinifera emoryi*

USA

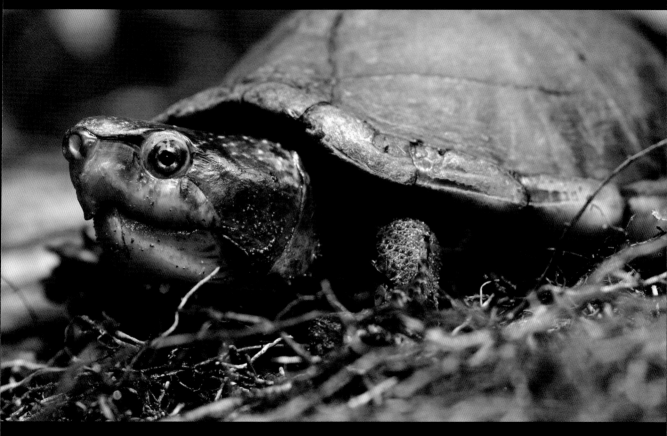

White-lipped Mud Turtle *Kinosternon leucostomum*

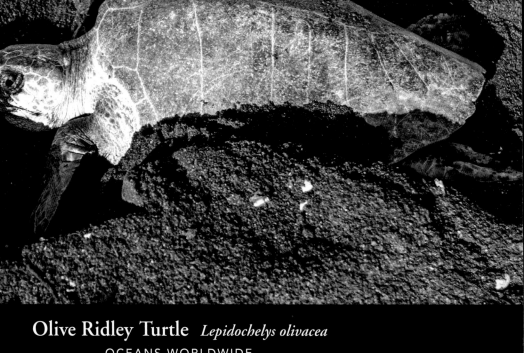

Olive Ridley Turtle *Lepidochelys olivacea*

OCEANS WORLDWIDE

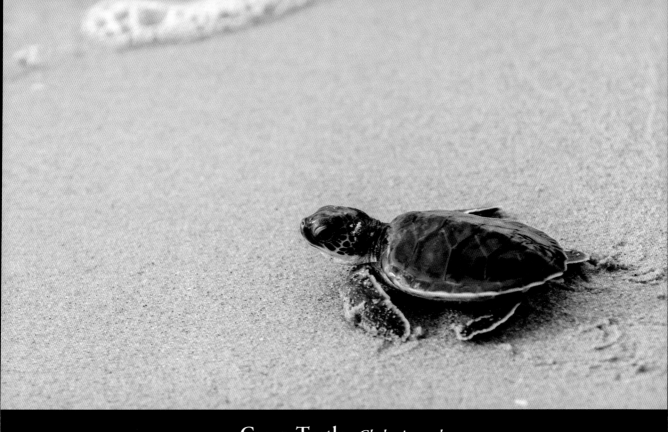

Green Turtle *Chelonia mydas*
OCEANS WORLDWIDE

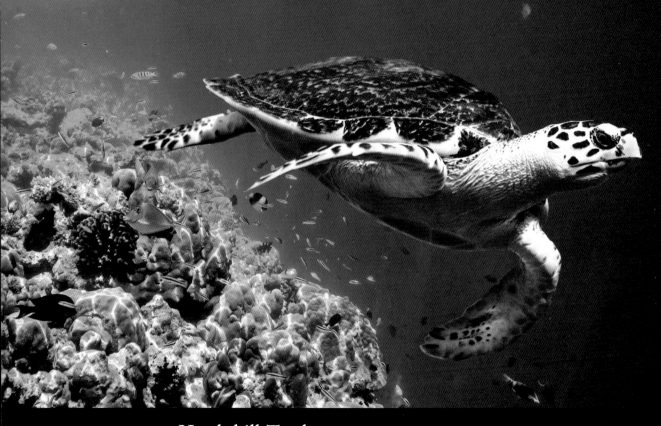

Hawksbill Turtle *Eretmochelys imbricata*

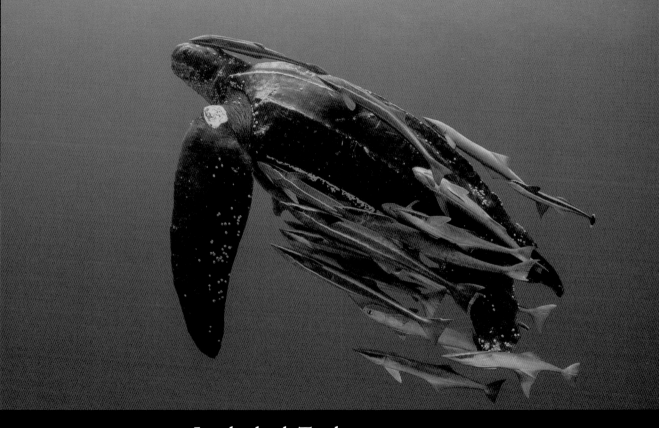

Leatherback Turtle *Dermochelys coriacea*

OCEANS WORLDWIDE

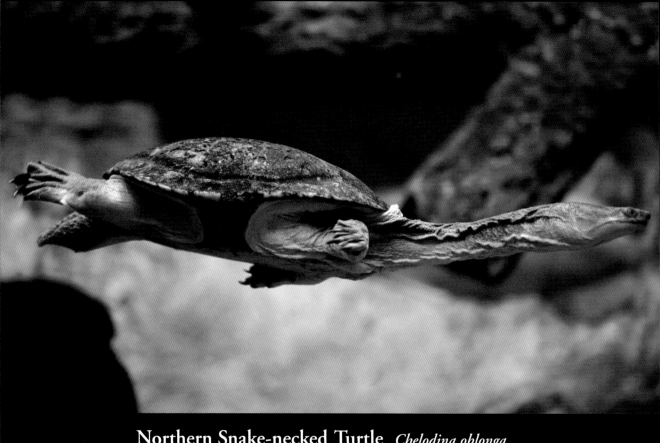

Northern Snake-necked Turtle *Chelodina oblonga*
AUSTRALIA

Mata Mata *Chelus fimbriatus*
SOUTH AMERICA

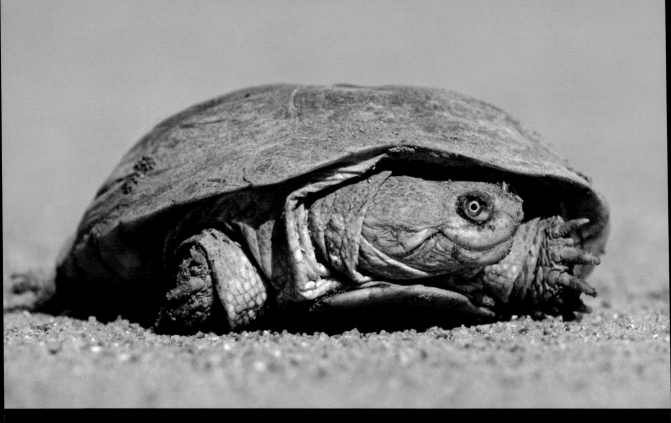

African Helmeted Turtle *Pelomedusa subrufa*

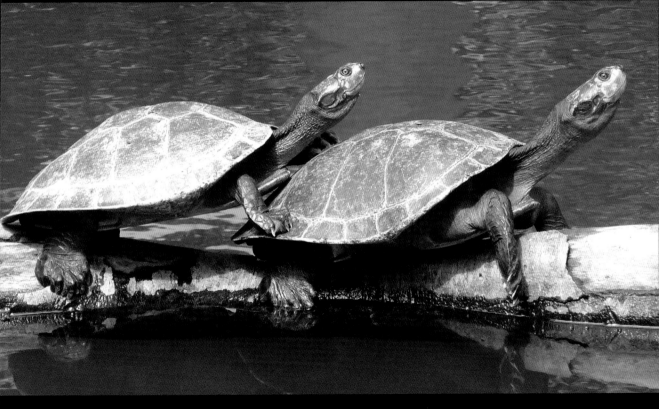

Big-headed Amazon River Turtle *Peltocephalus dumerilianus*
SOUTH AMERICA

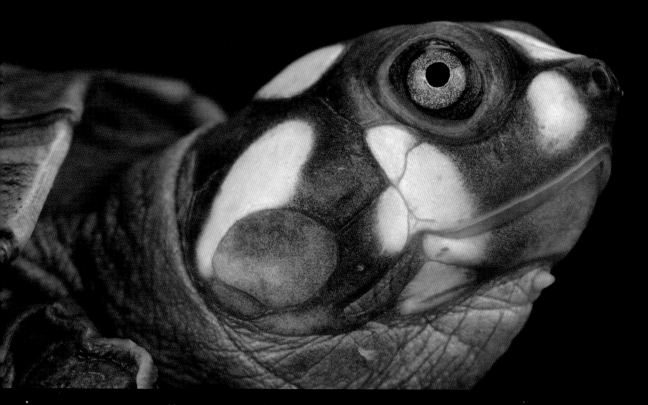

Yellow-spotted River Turtle *Podocnemis unifilis*
SOUTH AMERICA

Arrau Turtle *Podocnemis expansa*
SOUTH AMERICA

TUATARAS

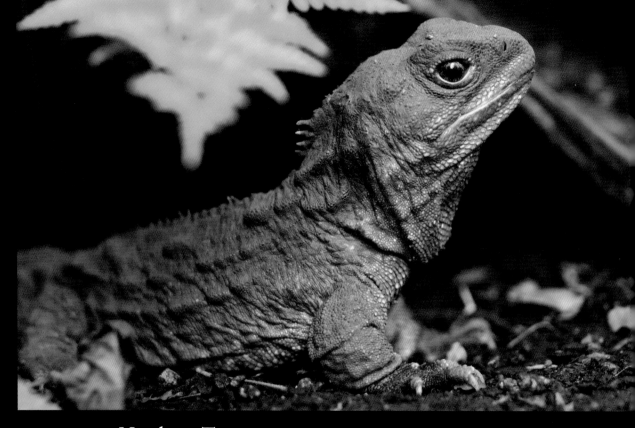

Northern Tuatara *Sphenodon punctatus punctatus*
NEW ZEALAND

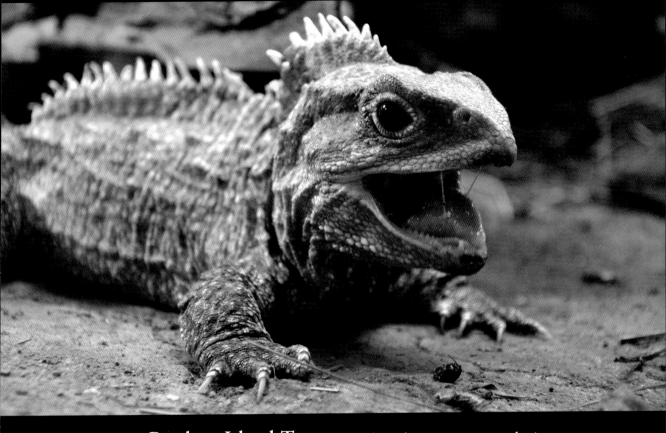

Brothers Island Tuatara *Sphenodon punctatus guntheri*
NEW ZEALAND

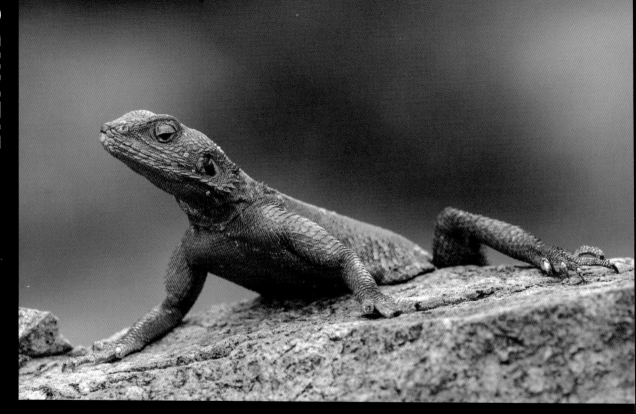

Common Agama or **Rainbow Agama** *Agama agama*
AFRICA

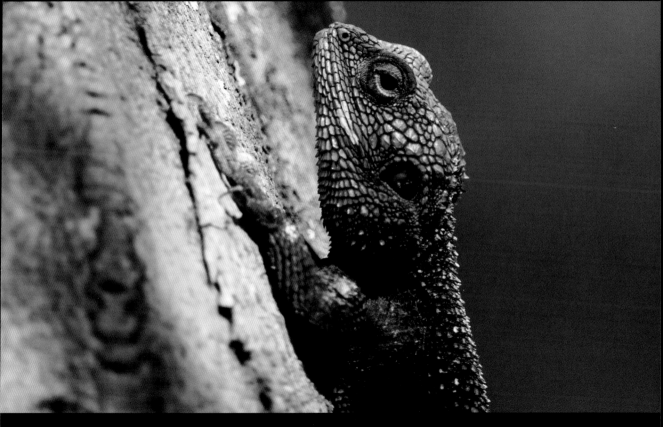

Black-necked Agama or **Blue-headed Tree Agama** *Acanthocercus atricollis*
AFRICA

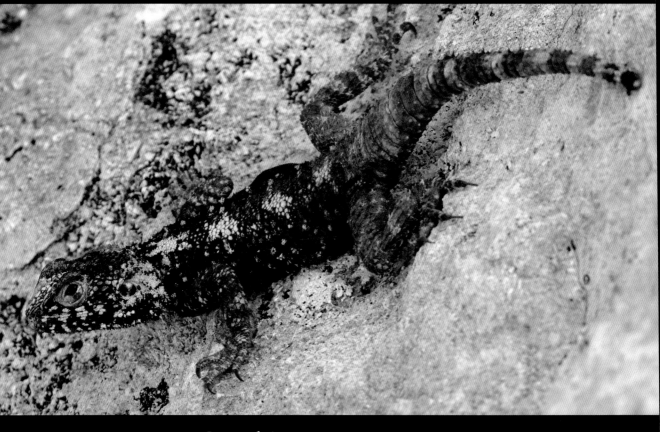

Starred Agama *Stellagama stellio*
SOUTH-EAST EUROPE AND SOUTH-WEST ASIA

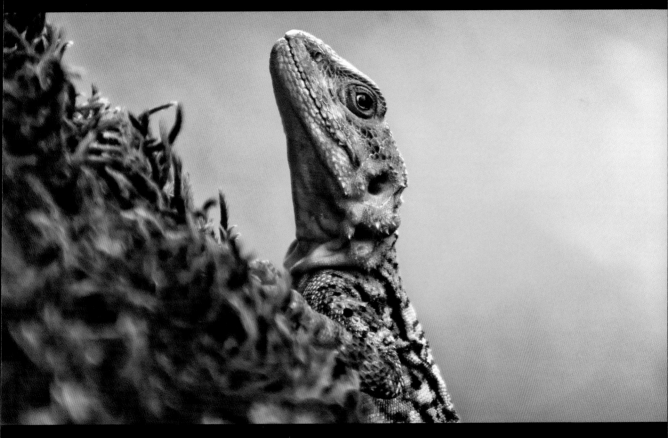

Caucasian Agama *Paralaudakia caucasia*
SOUTH-WEST ASIA

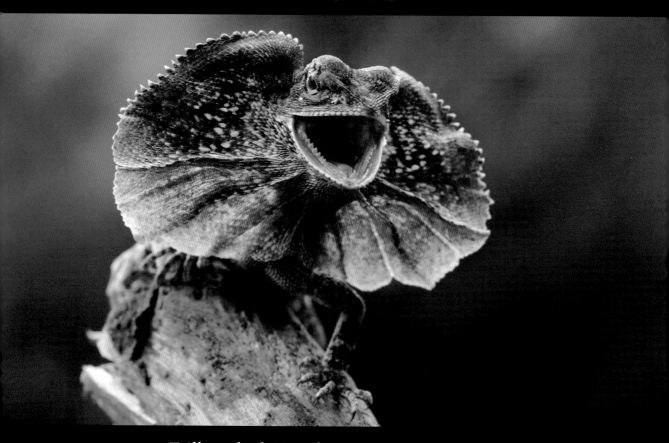

Frill-necked Lizard *Chlamydosaurus kingii*
AUSTRALIA

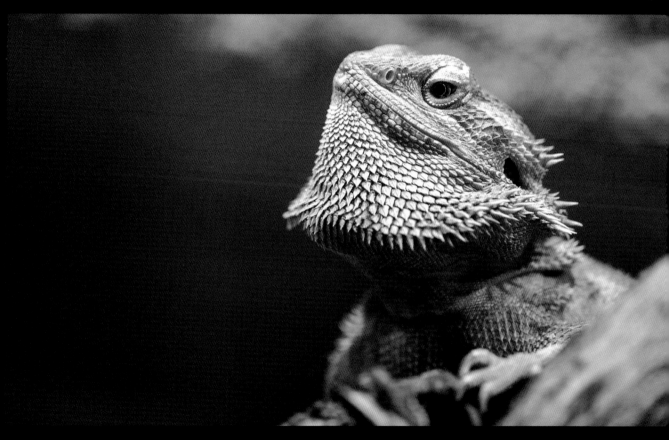

Central Bearded Dragon *Pogona vitticeps*
AUSTRALIA

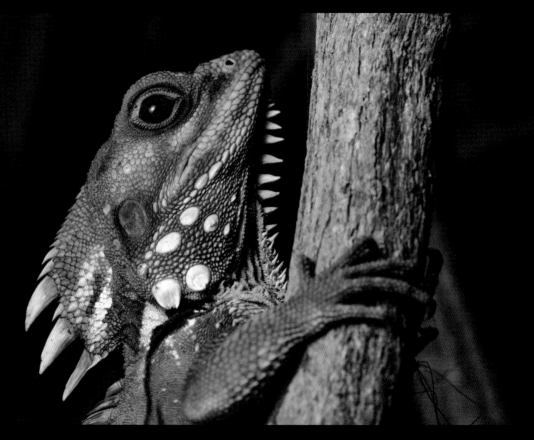

Boyd's Forest Dragon *Lophosaurus boydii*
AUSTRALIA

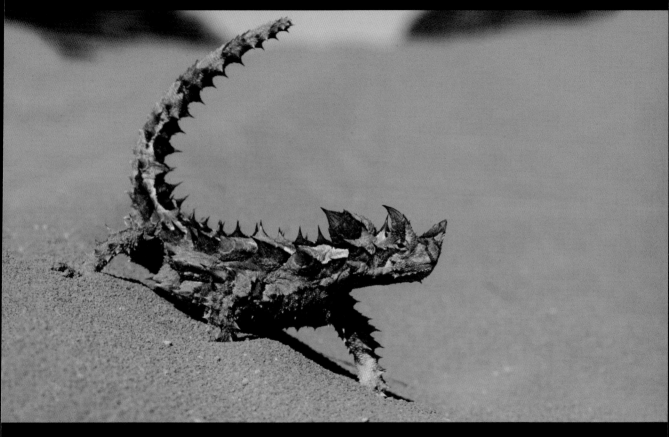

Thorny Devil *Moloch horridus*
AUSTRALIA

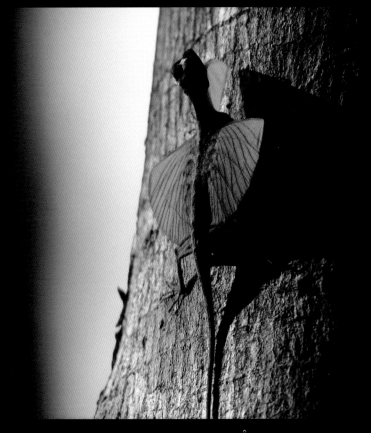

Sulawesi Lined Flying Lizard *Draco spilonotus*
INDONESIA

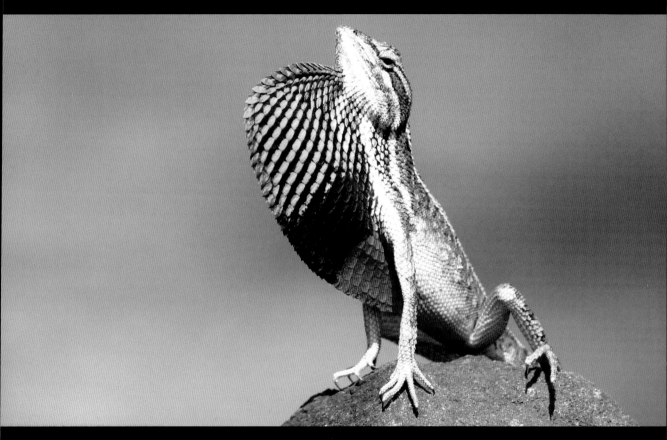

Fan-throated Lizard *Sitana ponticeriana*
SOUTH ASIA

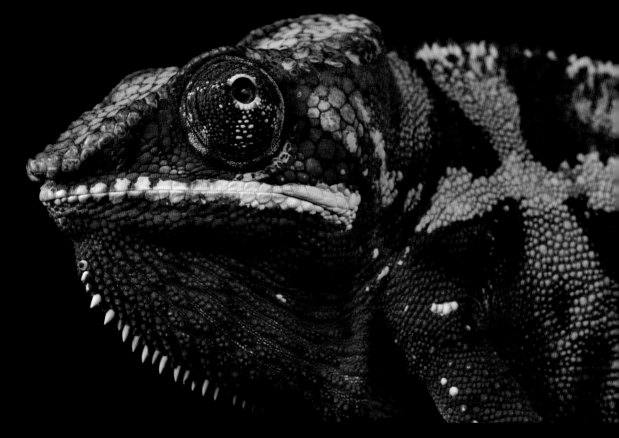

Panther Chameleon *Furcifer pardalis*
MADAGASCAR

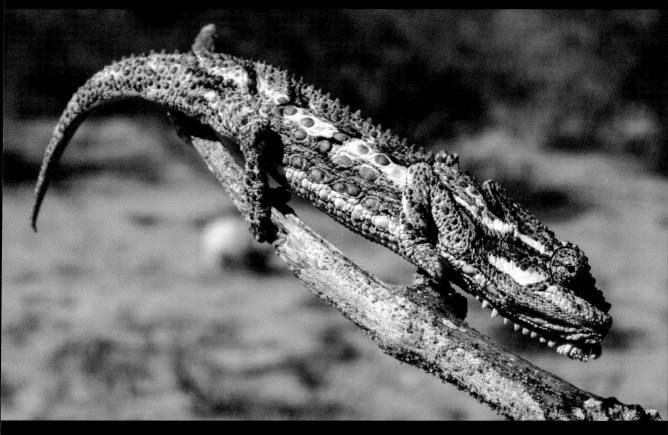

Namaqua Dwarf Chameleon *Bradypodion occidentale*

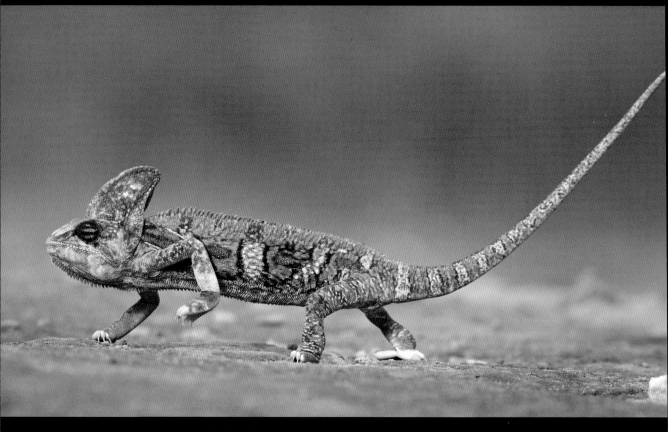

Veiled Chameleon · *Chamaeleo calyptratus*

ARABIA

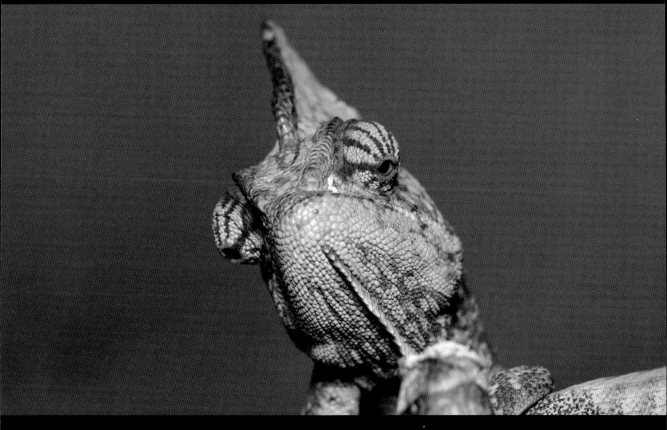

Veiled Chameleon *Chamaeleo calyptratus*
ARABIA

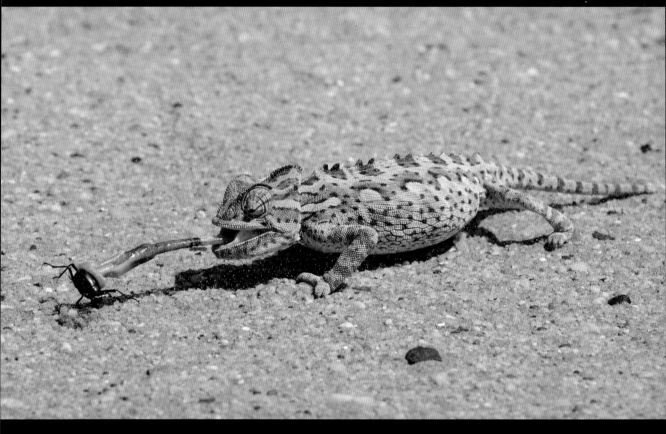

Namaqua Chameleon *Chamaeleo namaquensis*
SOUTHERN AFRICA

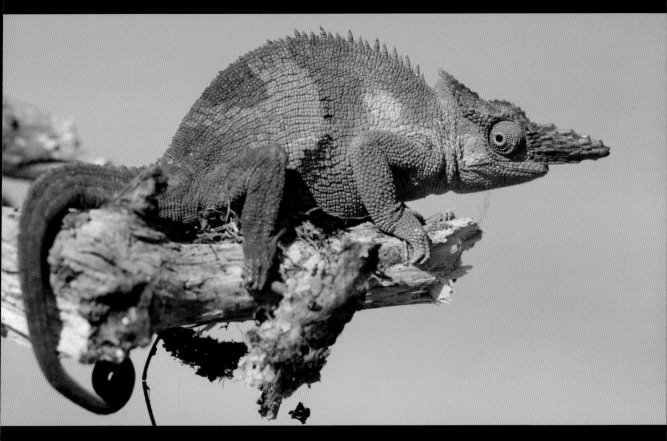

Fischer's Chameleon *Kinyongia fischeri*
TANZANIA

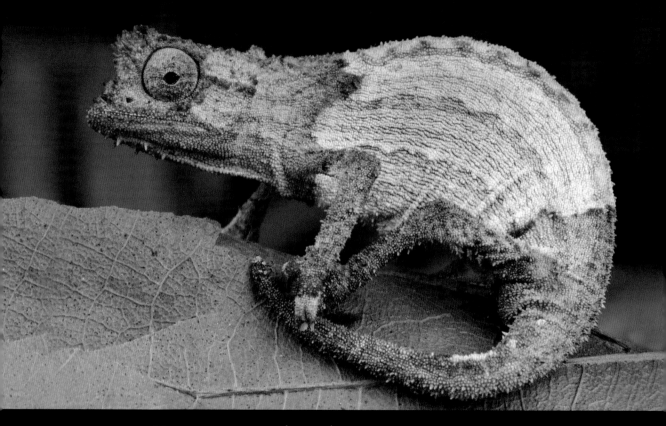

Kenya Pygmy Chameleon *Rieppeleon kerstenii*
EAST AFRICA

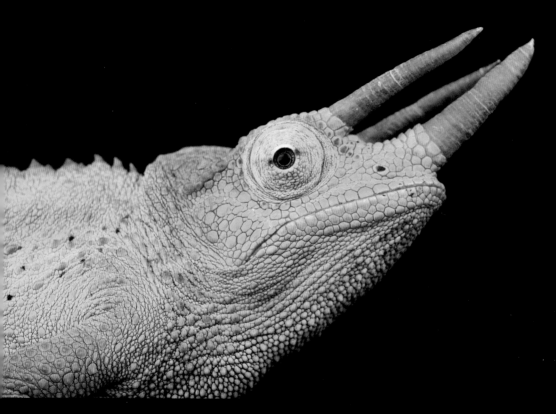

Jackson's Chameleon *Trioceros jacksonii*
EAST AFRICA

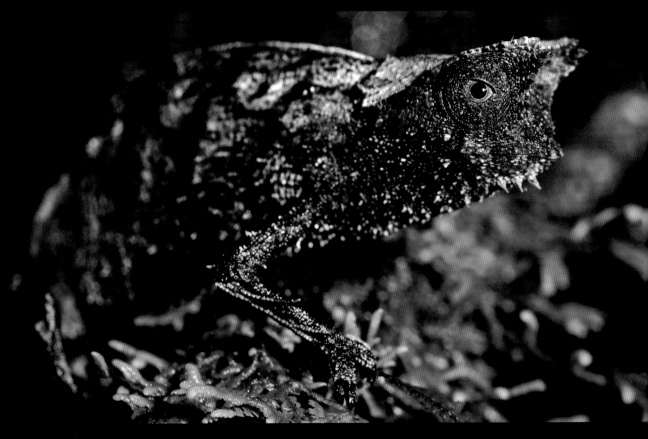

Brown Leaf Chameleon *Brookesia superciliaris*
MADAGASCAR

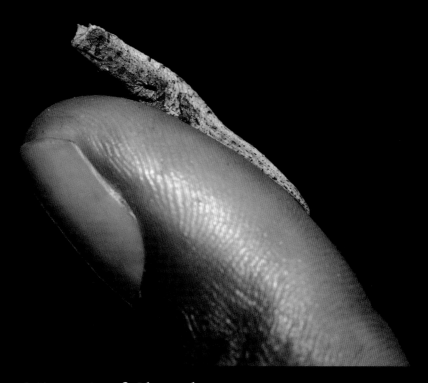

Minute Leaf Chameleon *Brookesia minima*
MADAGASCAR

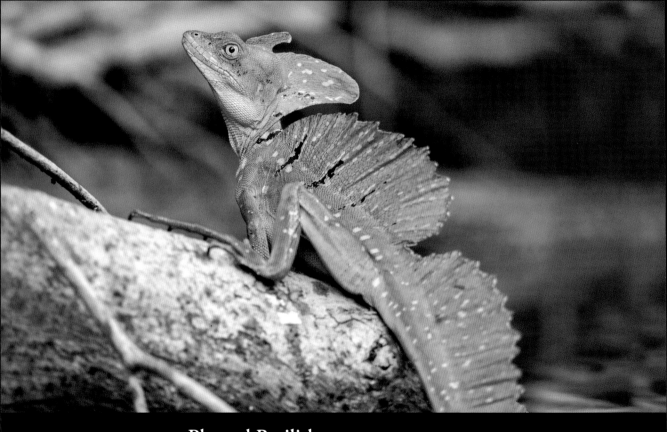

Plumed Basilisk *Basiliscus plumifrons*

CENTRAL AMERICA

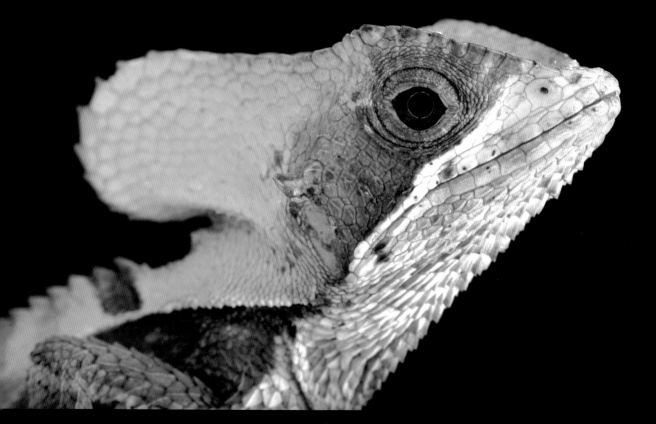

Hernandez's Helmeted Basilisk *Corytophanes hernandesii*
MEXICO

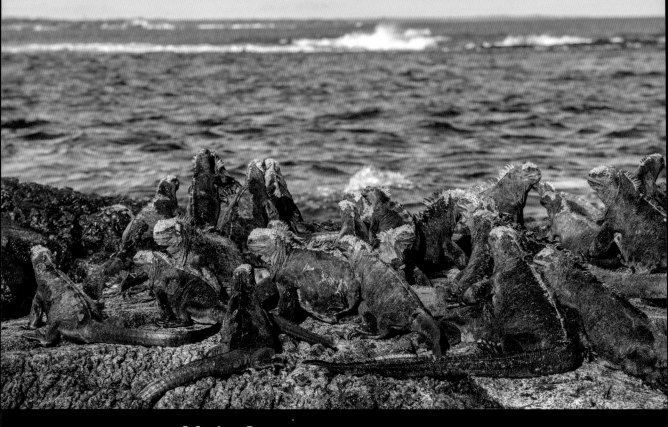

Marine Iguana *Amblyrhynchus cristatus*

GALÁPAGOS ISLANDS

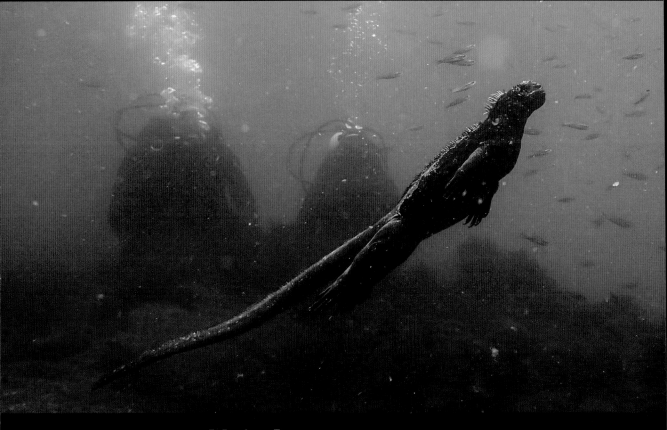

Marine Iguana *Amblyrhynchus cristatus*
GALÁPAGOS ISLANDS

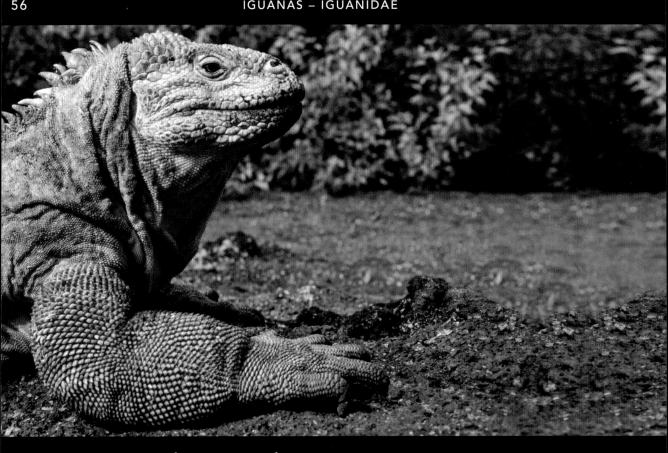

Galápagos Land Iguana *Conolophus subcristatus*
GALÁPAGOS ISLANDS

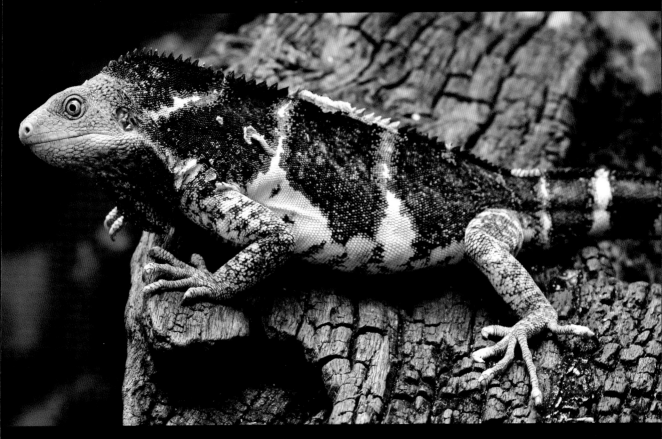

Fiji Crested Iguana *Brachylophus vitiensis*
FIJI

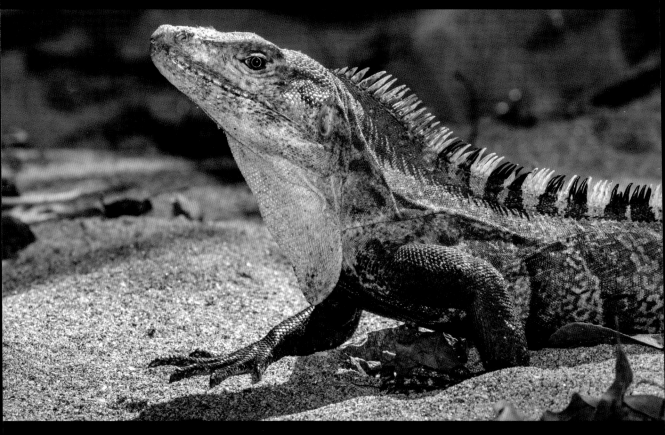

Black Spiny-tailed Iguana *Ctenosaura similis*

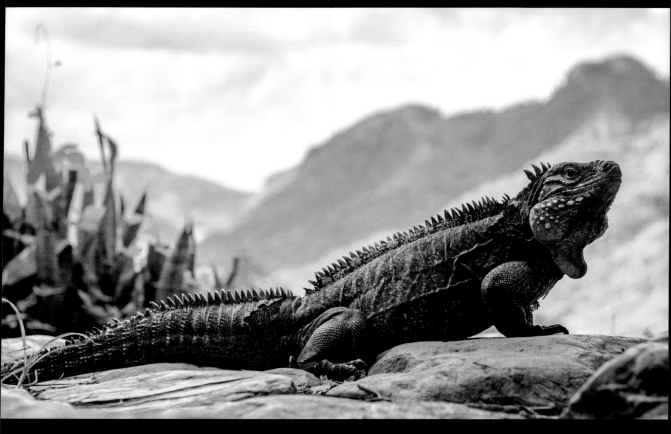

Cuban Rock Iguana *Cyclura nubila*
CUBA

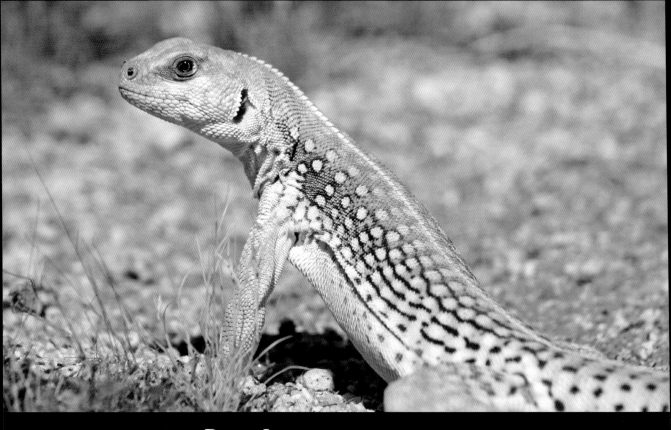

Desert Iguana *Dipsosaurus dorsalis*
NORTH AMERICA

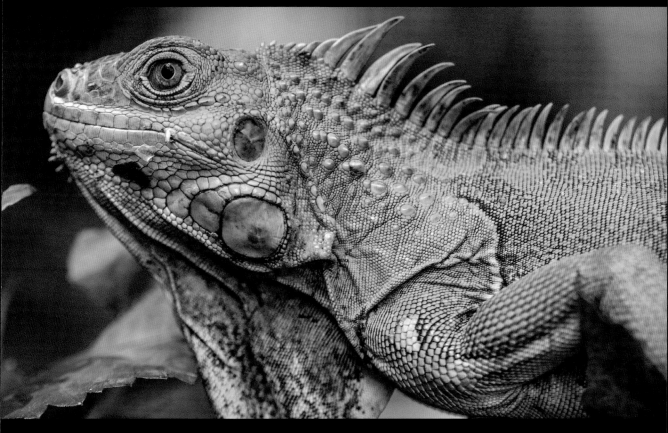

Green Iguana *Iguana iguana*

SOUTH AMERICA, CENTRAL AMERICA AND THE CARIBBEAN

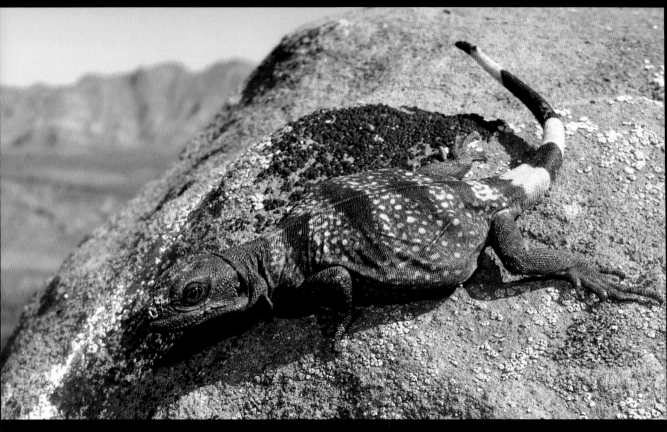

Chuckwalla *Sauromalus ater*

NORTH AMERICA

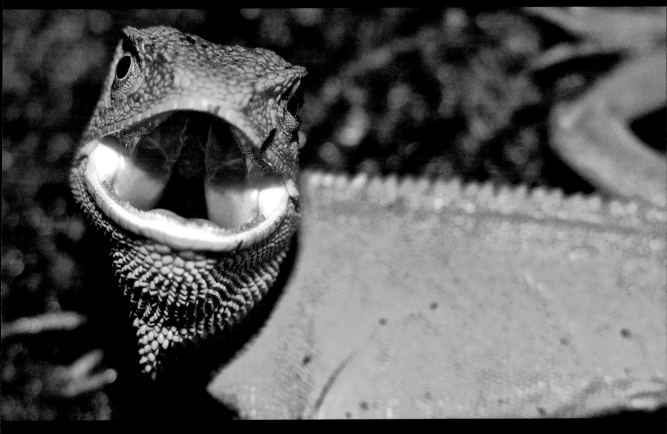

Green Tree Lizard *Enyalius iheringi*

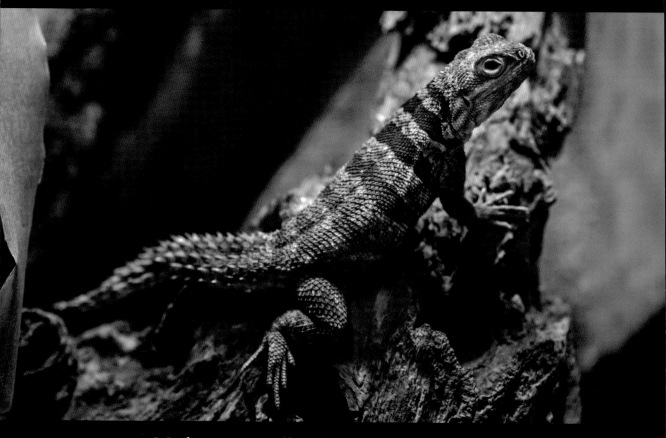

Madagascan Collared Iguana *Oplurus cuvieri*

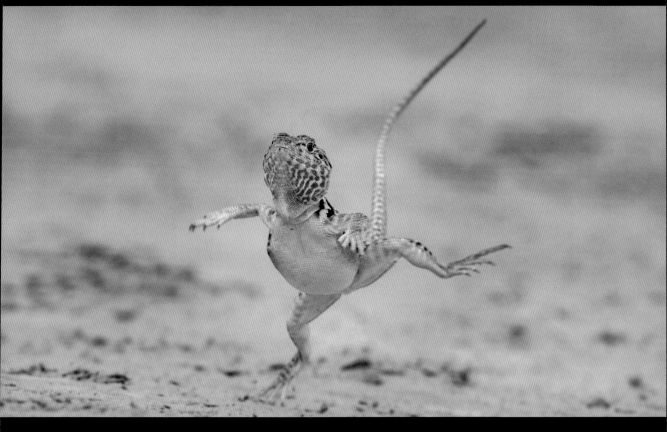

Common Collared Lizard *Crotaphytus collaris*

NORTH AMERICA

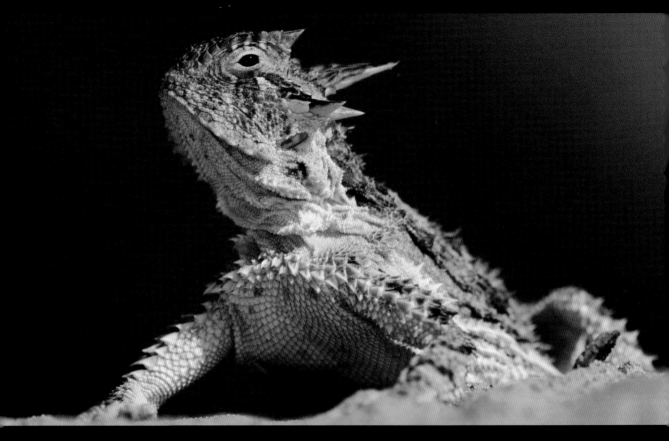

Texas Horned Lizard *Phrynosoma cornutum*
NORTH AMERICA

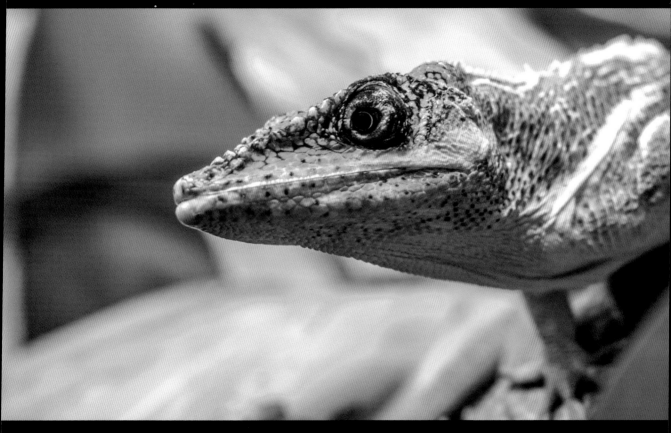

Knight Anole *Anolis equestris*
CUBA

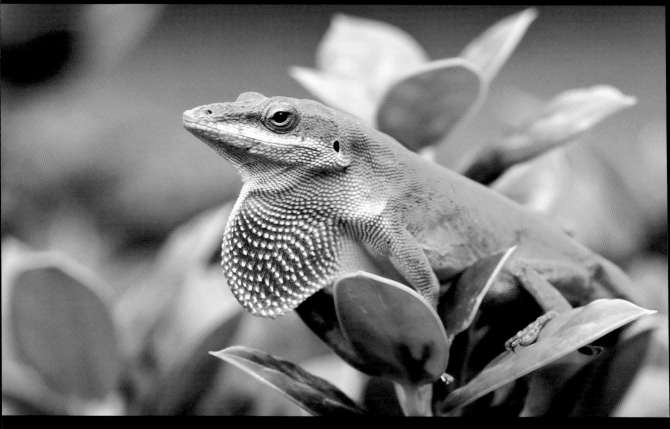

Green Anole *Anolis carolinensis*
NORTH AMERICA

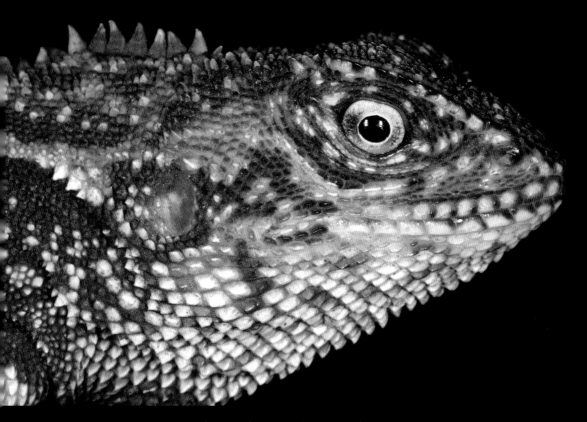

Red-eyed Wood Lizard *Enylioides oshaughnessyi*
SOUTH AMERICA

Western Leaf Lizard *Stenocercus fimbriatus*
SOUTH AMERICA

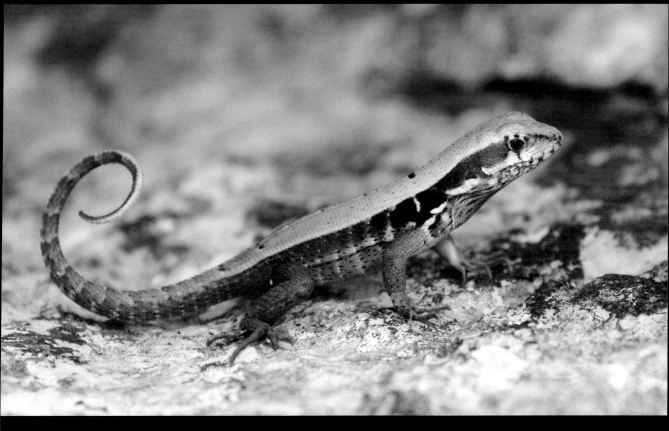

Cuban Curlytail Lizard *Leiocephalus cubensis*

CUBA

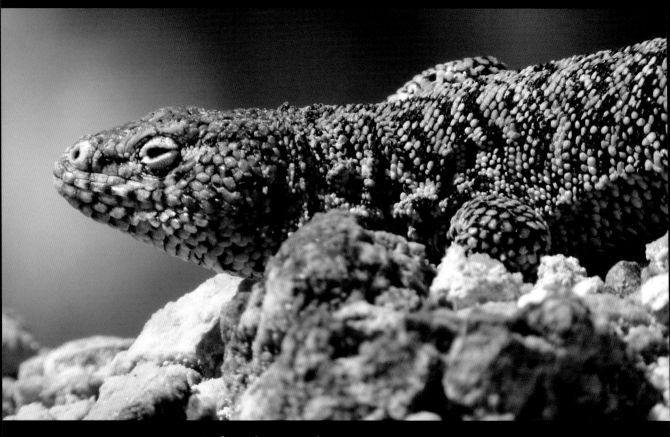

Fabian's Lizard *Liolaemus fabiani*

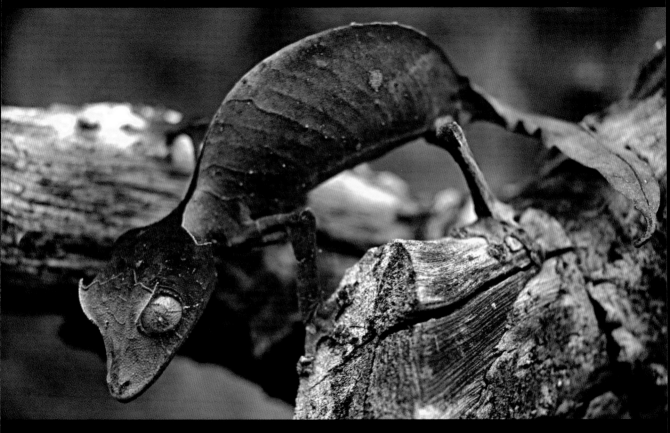

Satanic Leaf-tailed Gecko *Uroplatus phantasticus*
MADAGASCAR

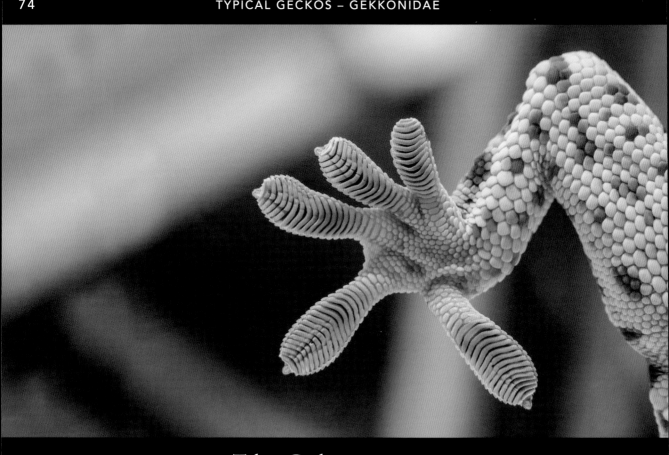

Tokay Gecko *Gekko gekko*

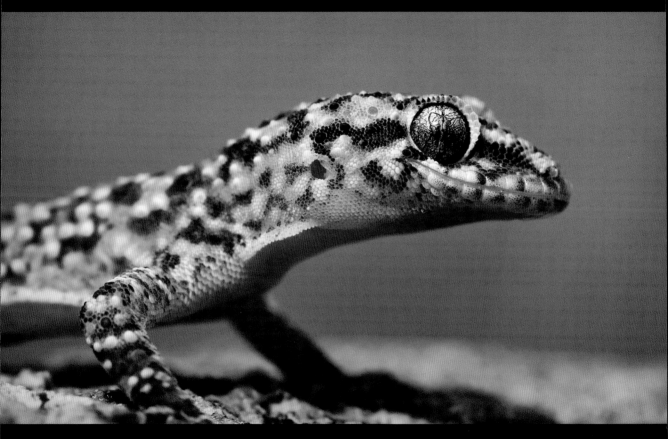

Mediterranean House Gecko *Hemidactylus turcicus*

MEDITERRANEAN

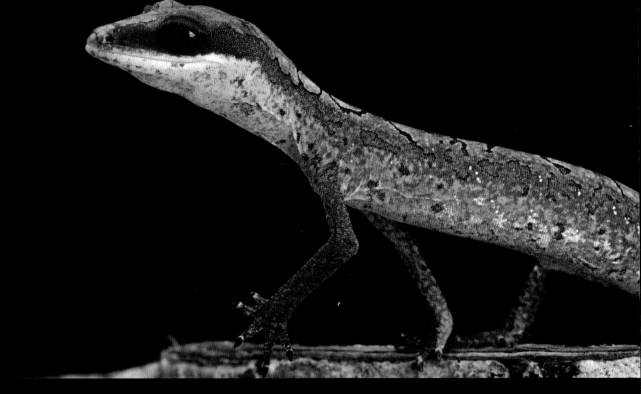

Cat Gecko *Aeluroscalabotes felinus*
SOUTH-EAST ASIA

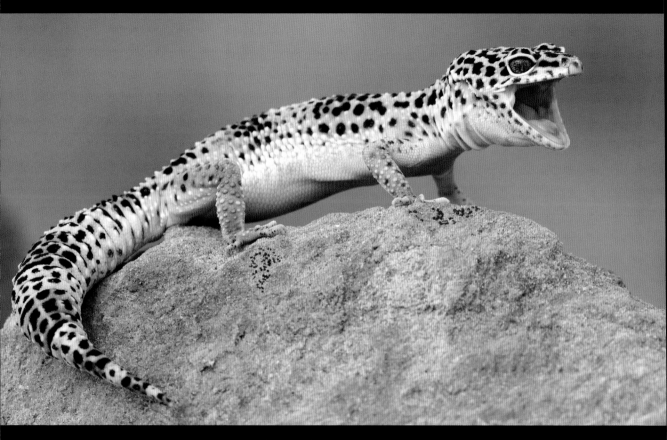

Leopard Gecko *Eublepharis macularius*
SOUTH ASIA

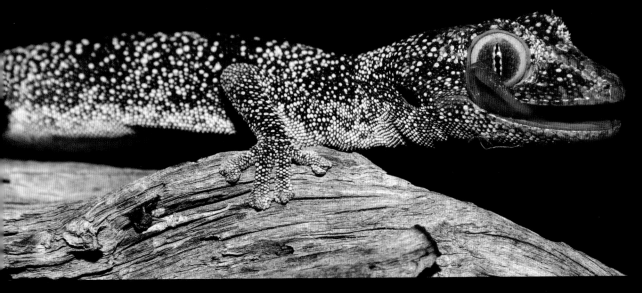

Northern Spiny-tailed Gecko *Strophurus ciliaris*
AUSTRALIA

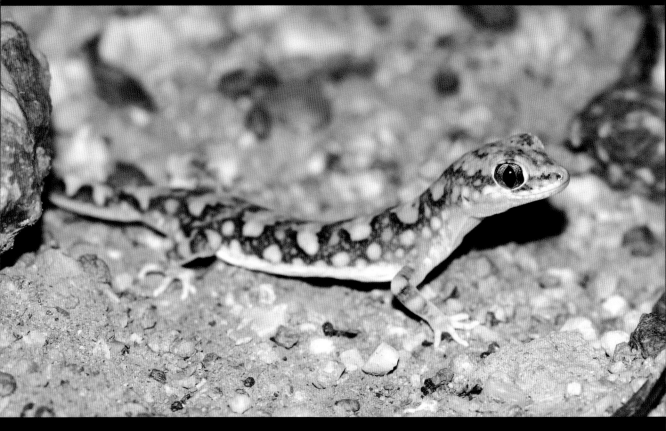

Main's Ground Gecko *Lucasium mainii*
AUSTRALIA

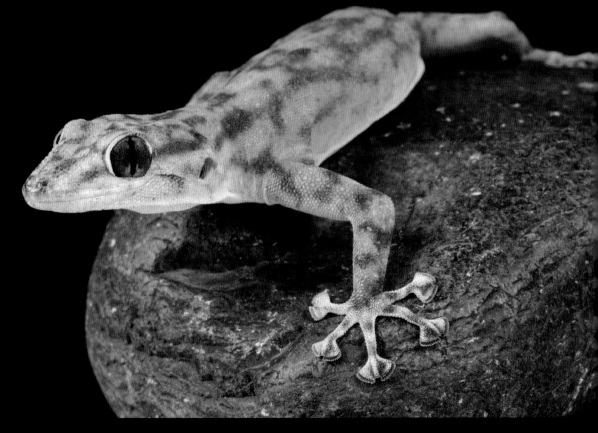

Ragazzi's Fan-footed Gecko *Ptyodactylus ragazzi*
AFRICA

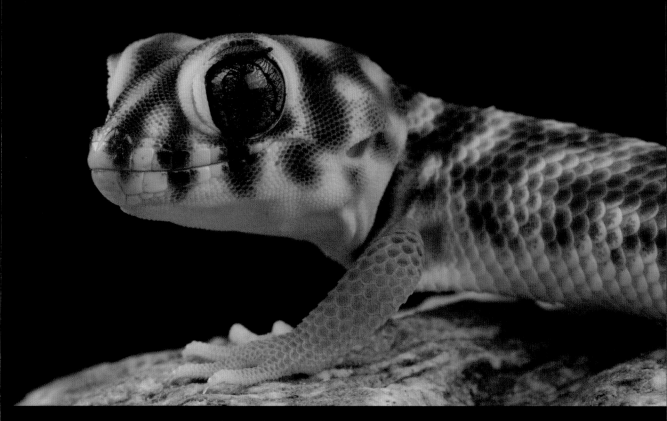

Wonder Gecko *Teratoscincus scincus*
ASIA

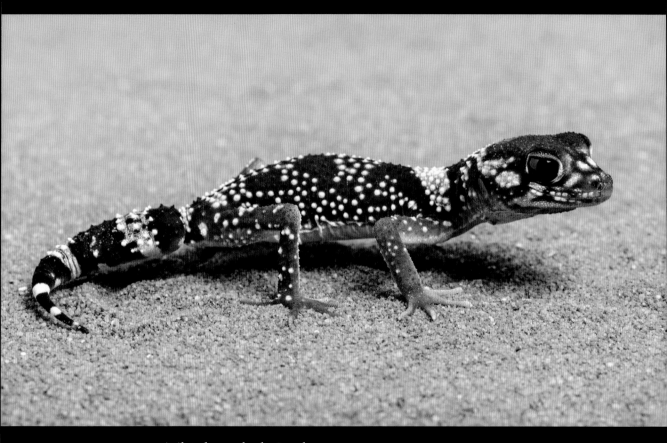

Thick-tailed Gecko *Underwoodisaurus milii*

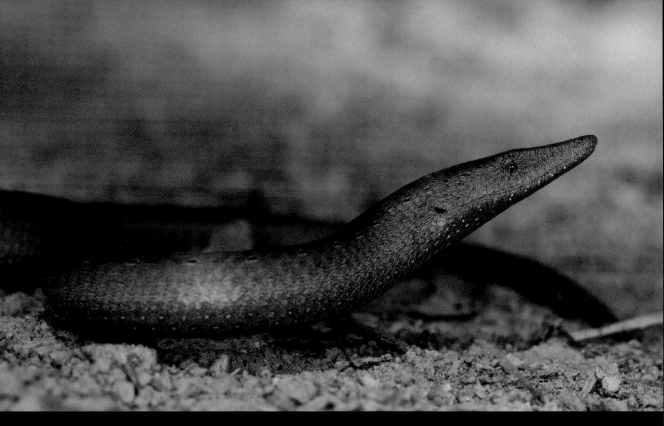

Burton's Legless Lizard *Lialis burtonis*
AUSTRALIA

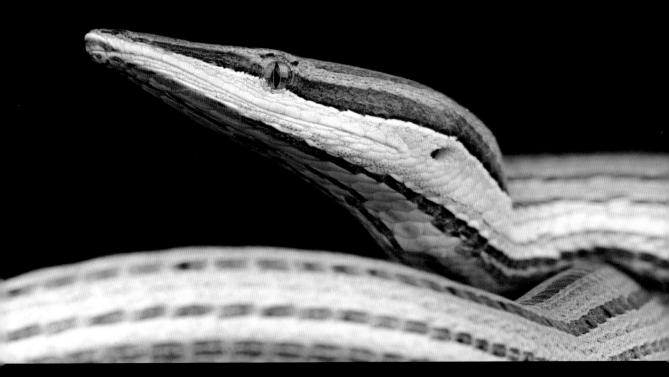

Papua Legless Lizard *Lialis jicari*
NEW GUINEA

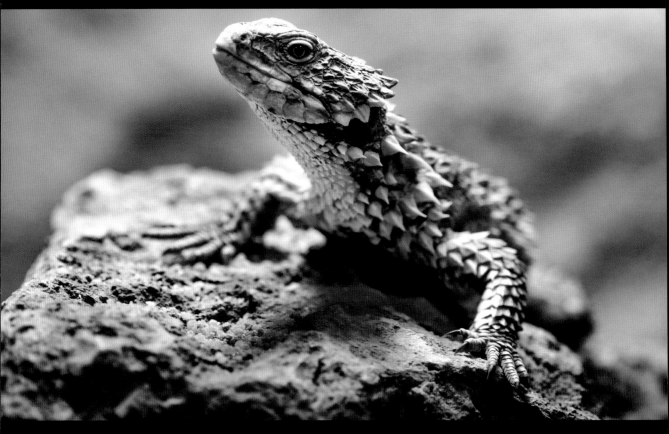

Sungazer or **Giant Girdled Lizard** *Smaug giganteus*
SOUTH AFRICA

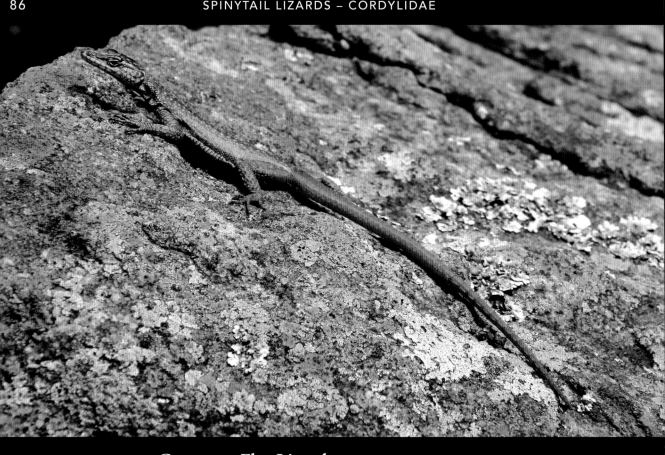

Common Flat Lizard *Platysaurus intermedius*

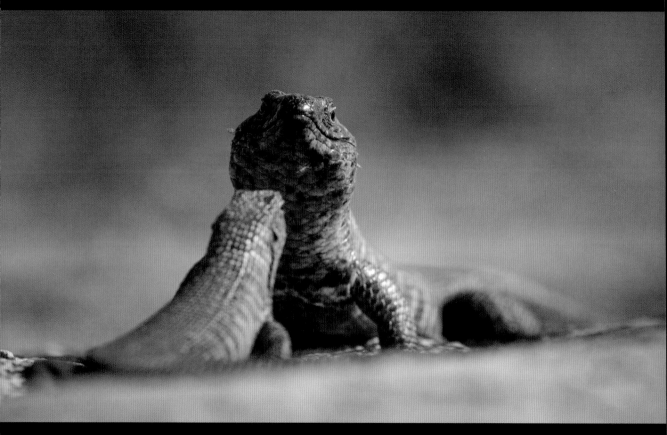

Giant Plated Lizard *Gerrhosaurus validus*
AFRICA

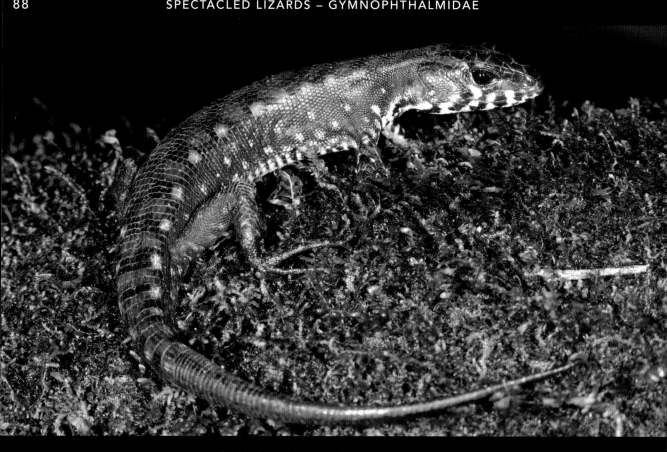

Gymnophthalmid lizard species *Potamites* sp.

SOUTH AMERICA

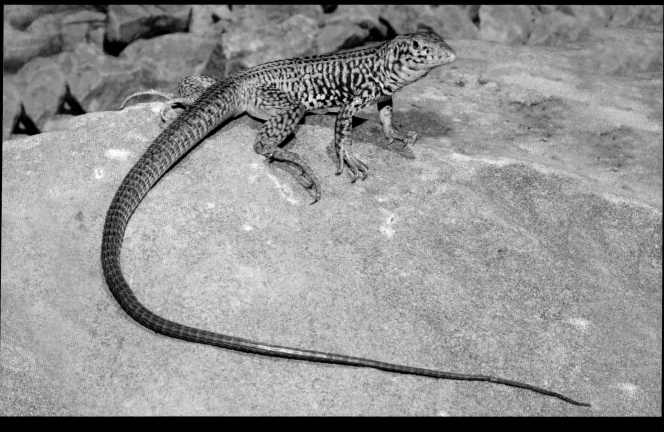

Western Whiptail *Aspidoscelis tigris*
SOUTH AMERICA

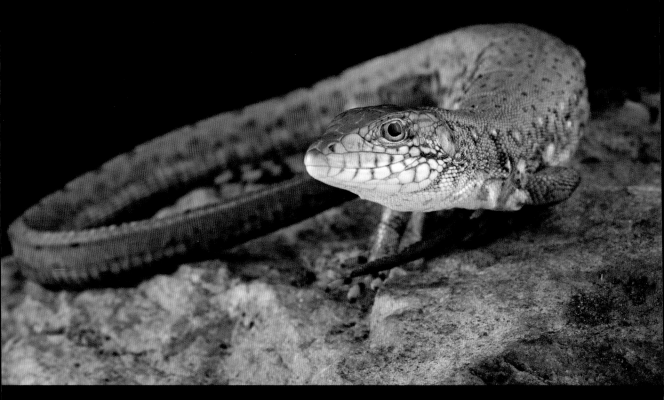

Crocodile Tegu *Crocodilurus amazonicus*
SOUTH AMERICA

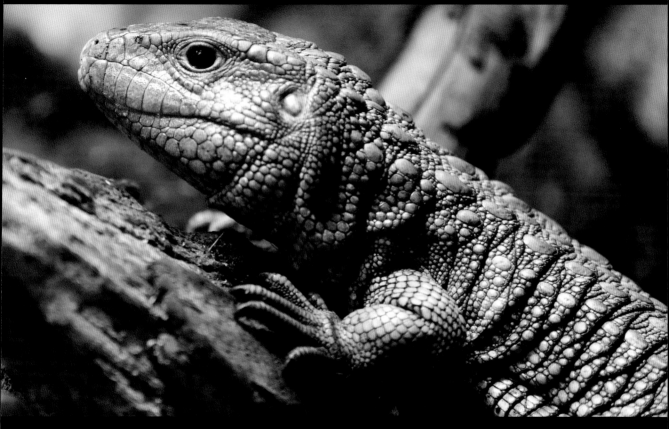

Northern Caiman Lizard *Dracaena guianensis*

SOUTH AMERICA

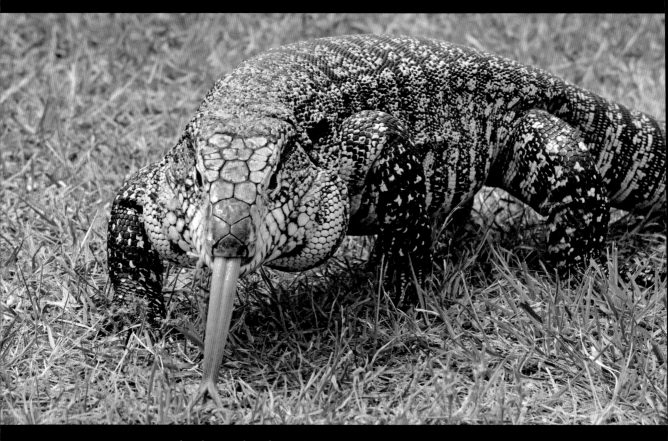

Black-and-white Tegu *Tupinambis merianae*
SOUTH AMERICA

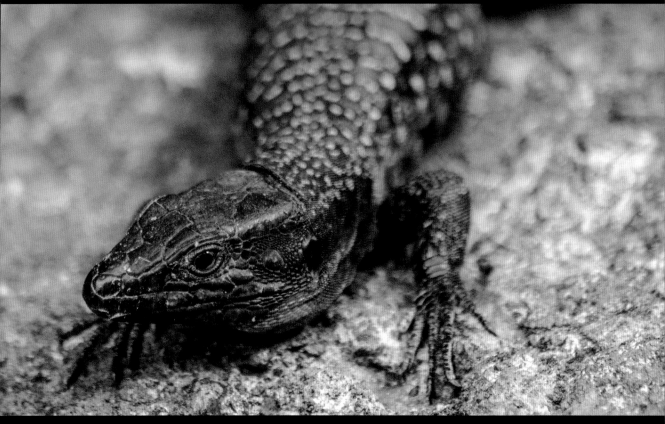

Tenerife Lizard *Gallotia galloti*

CANARY ISLANDS

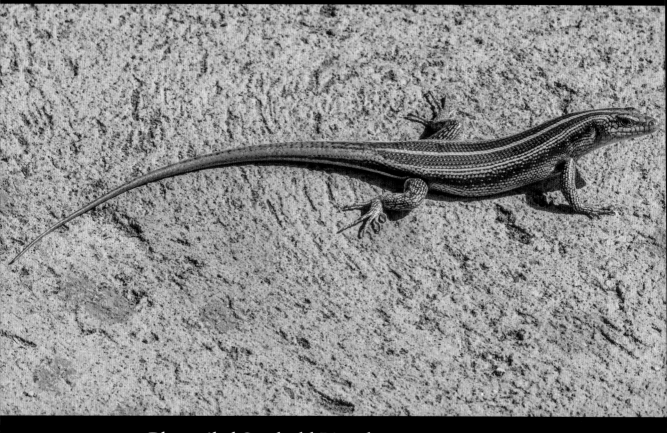

Blue-tailed Sandveld Lizard *Nucras caesicaudata*
AFRICA

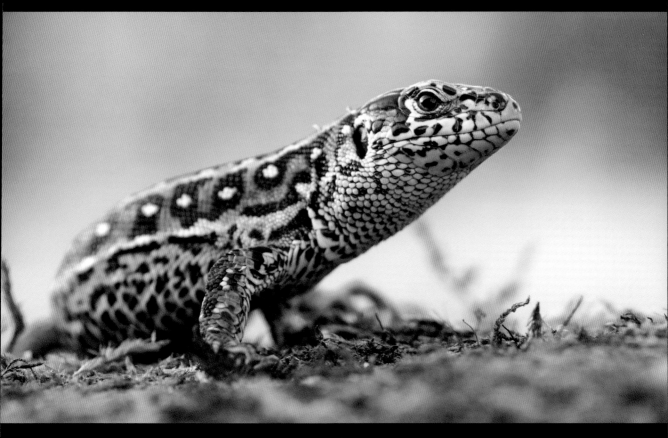

Sand Lizard *Lacerta agilis*

EURASIA

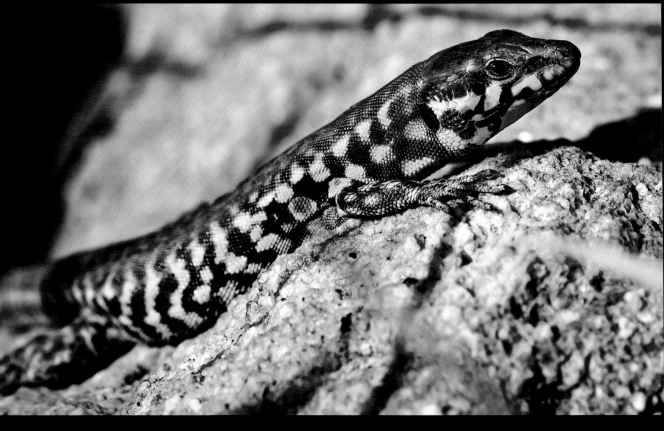

Milos Wall Lizard *Podarcis milensis*
GREECE

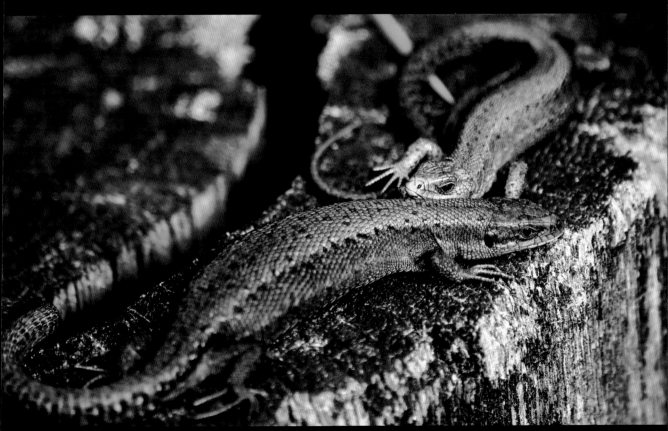

Common Lizard *Zootoca vivipara*

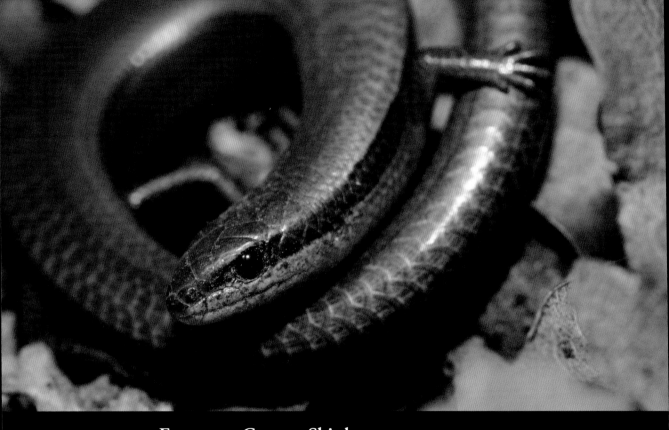

European Copper Skink *Ablepharus kitaibelii*
EURASIA

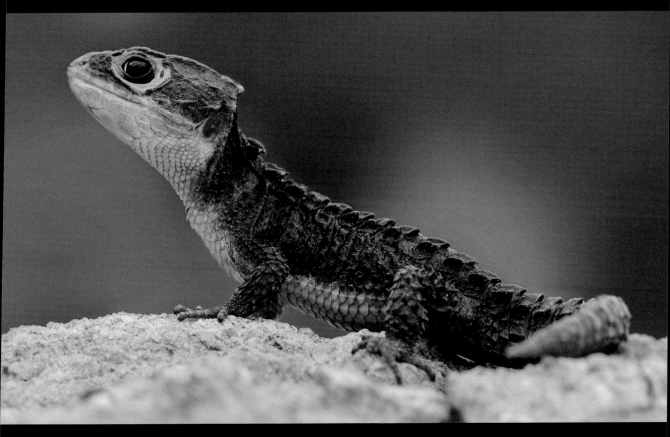

Red-eyed Crocodile Skink *Tribolonotus gracilis*

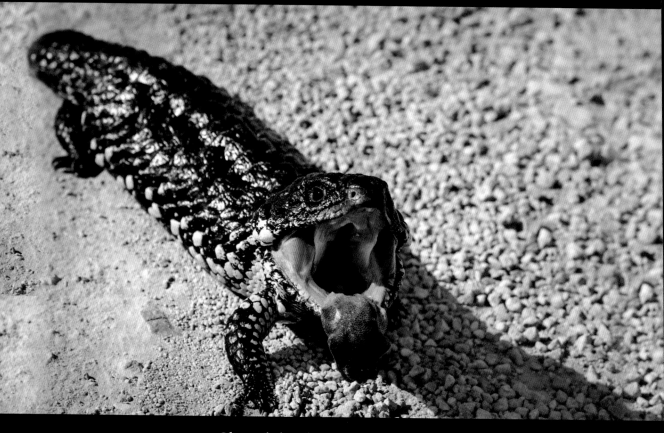

Shingleback *Tiliqua rugosa*
AUSTRALIA

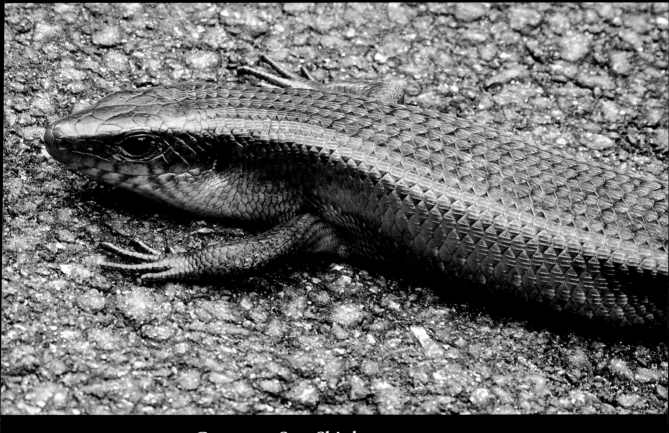

Common Sun Skink *Eutropis multifasciata*
SOUTH ASIA

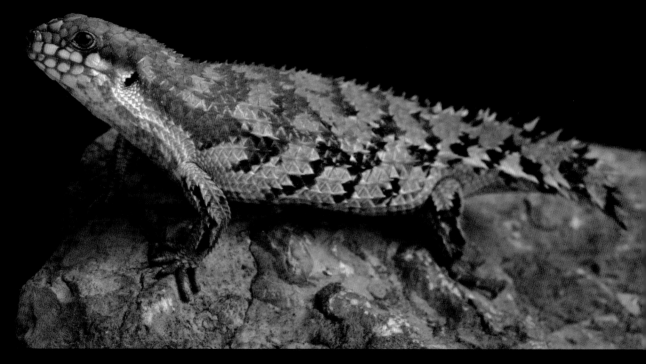

Pygmy Spiny-tailed Skink *Egernia depressa*
AUSTRALIA

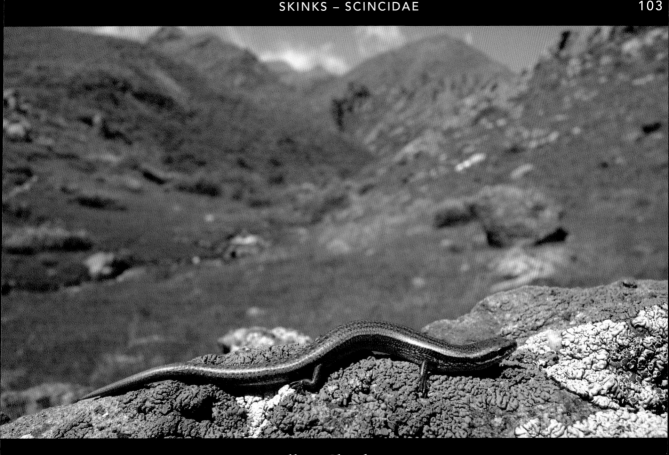

Desert Lidless Skink *Ablepharus deserti*

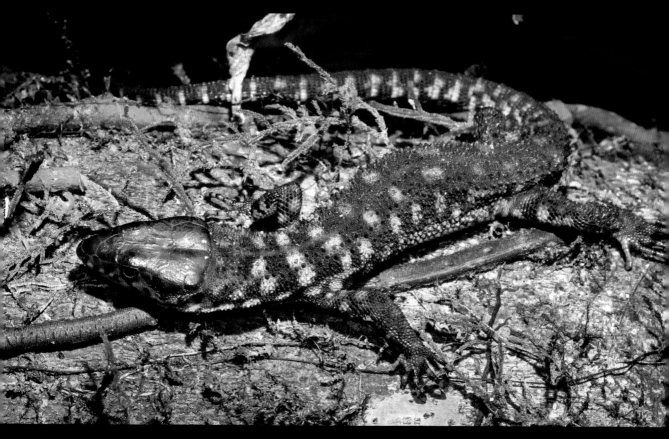

Yellow-spotted Night Lizard *Lepidophyma flavimaculatum*
CENTRAL AMERICA

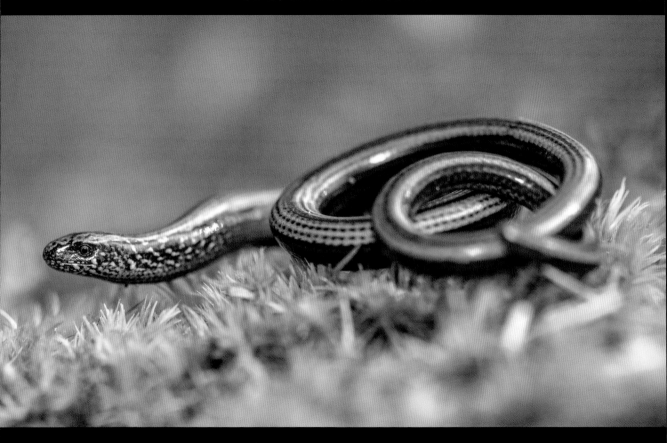

Slow-worm *Anguis fragilis*
EURASIA

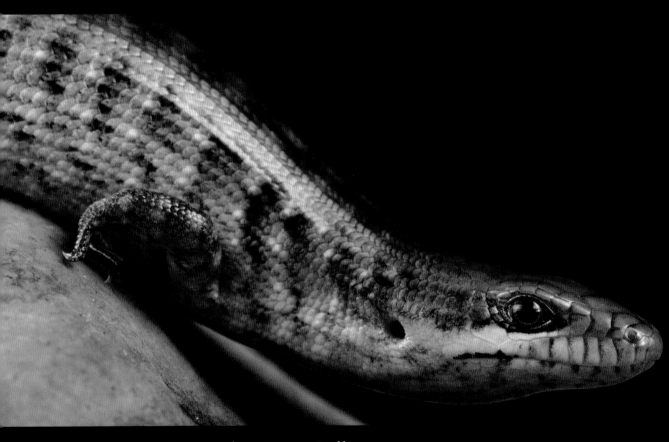

Hispaniolan Giant Galliwasp *Celestus warreni*
HISPANIOLA

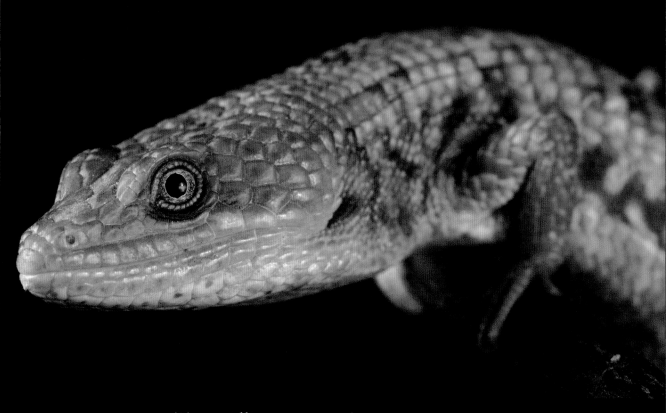

Texas Alligator Lizard *Gerrhonotus infernalis*
NORTH AMERICA

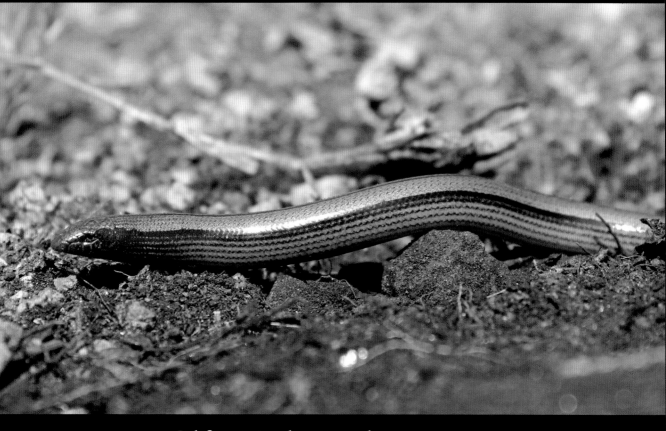

California Legless Lizard *Anniella pulchra*
NORTH AMERICA

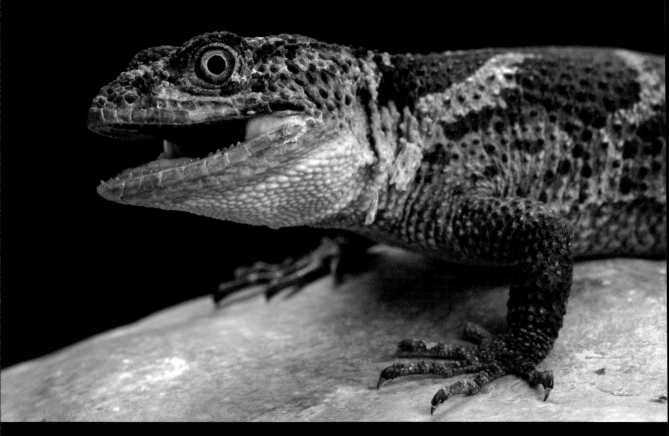

Newman's Knob-scaled Lizard *Xenosaurus newmanorum*
MEXICO

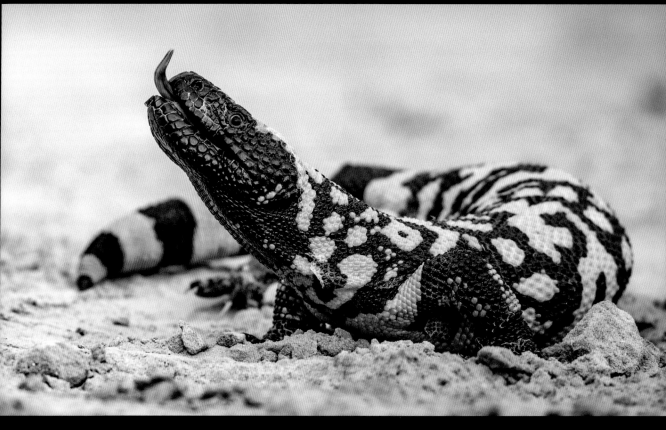

Gila Monster *Heloderma suspectum*

MEXICO AND USA

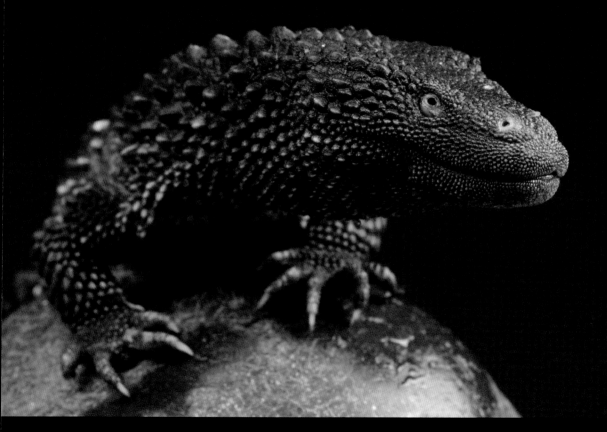

Earless Monitor Lizard *Lanthanotus borneensis*
BORNEO

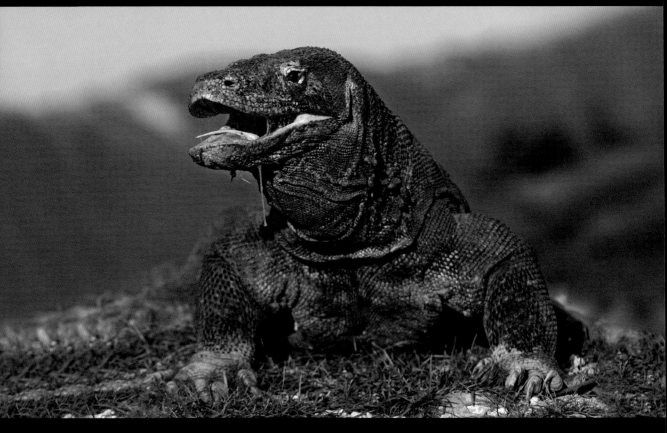

Komodo Dragon *Varanus komodoensis*

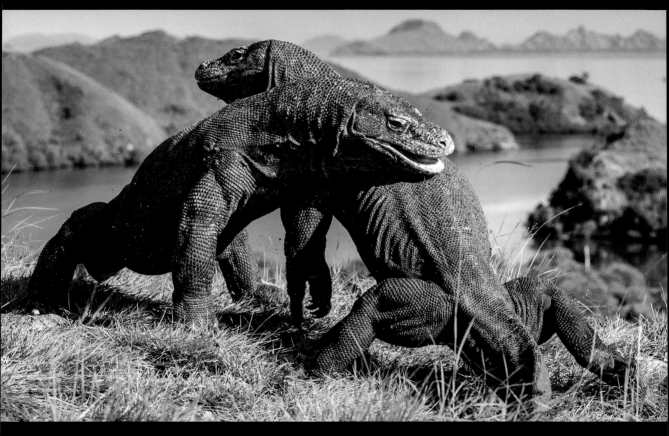

Komodo Dragon *Varanus komodoensis*
INDONESIA

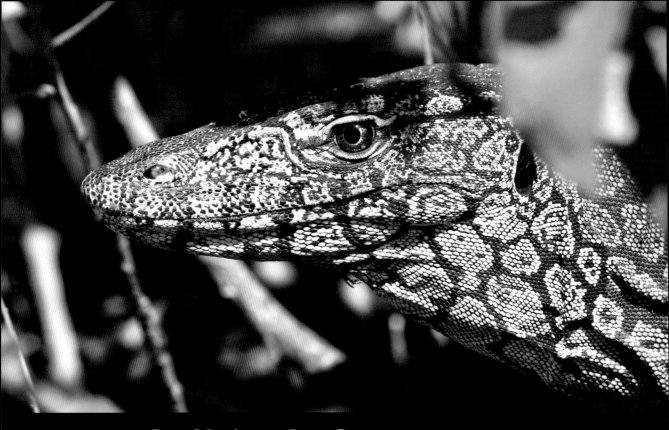

Lace Monitor or **Lace Goanna** *Varanus varius*
AUSTRALIA

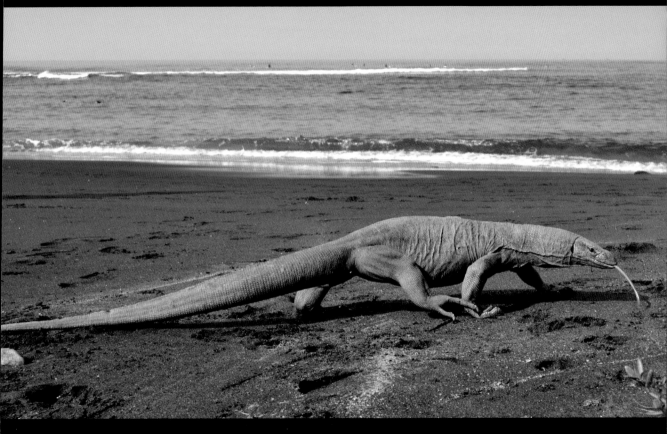

Bengal Monitor *Varanus bengalensis*
SOUTH ASIA

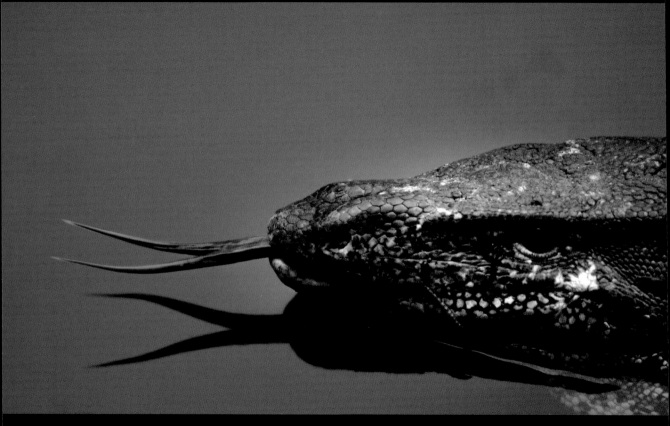

Asian Water Monitor *Varanus salvator*
SOUTH ASIA

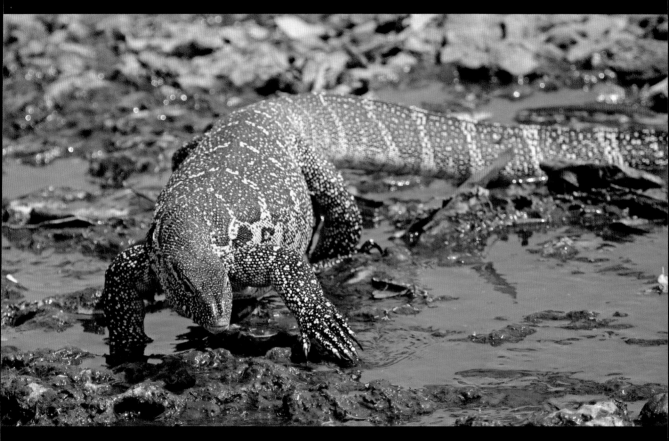

Nile Monitor *Varanus niloticus*
AFRICA

AMPHISBAENIANS

Wedge-snouted Worm Lizard *Monopeltis decosteri*
AFRICA

Zarudny's Worm Lizard *Diplometopon zarudnyi*
SOUTH-WEST ASIA

SNAKES

Javan File Snake or **Elephant Trunk Snake** *Acrochordus javanicus*
SOUTH ASIA

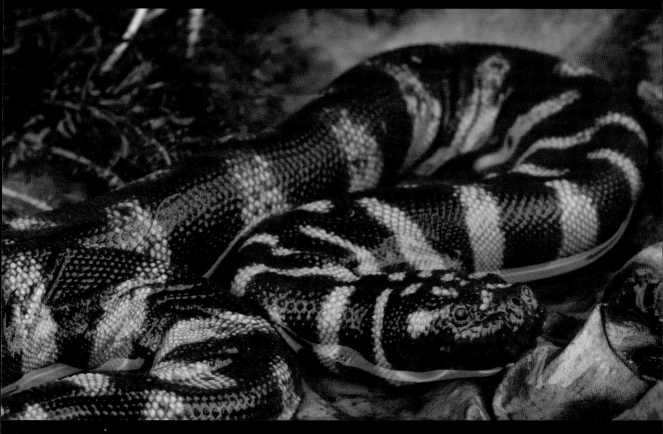

Little File Snake *Acrochordus granulatus*

SOUTH ASIA AND NORTH AUSTRALIA

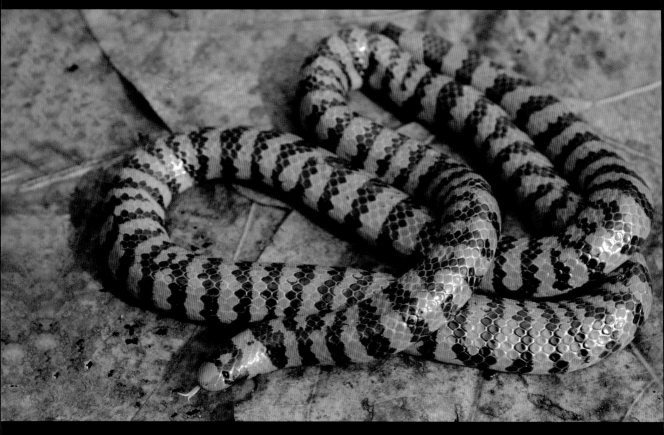

American Pipe Snake or **False Coral Snake** *Anilius scytale*

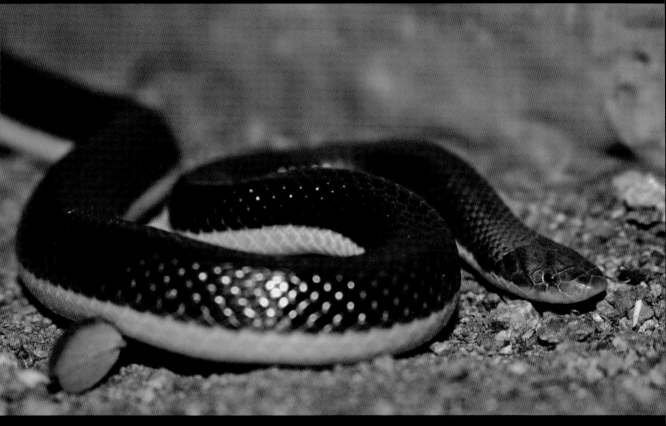

Southern Stiletto Snake *Atractaspis bibronii*
AFRICA

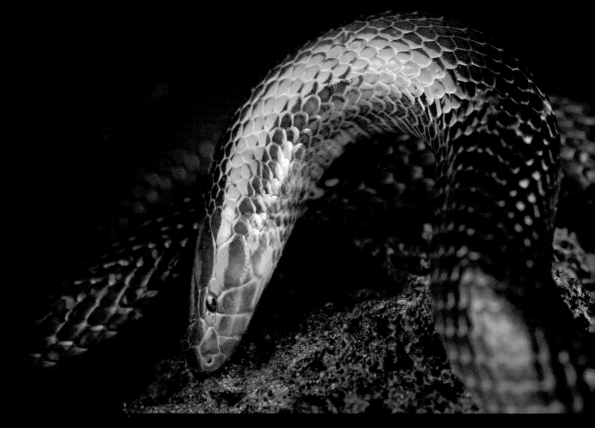

Variable Burrowing Asp *Atractaspis irregularis*
AFRICA

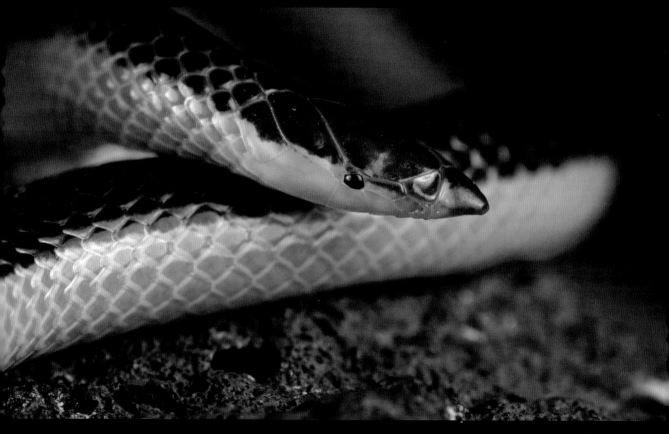

Striped Quill-snouted Snake *Xenocalamus bicolor lineatus*

AFRICA

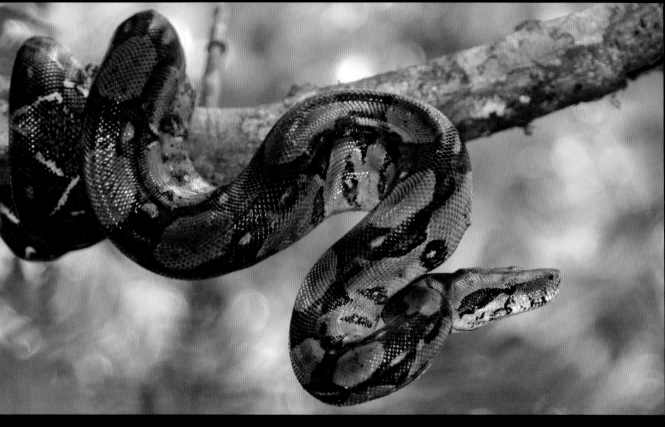

Northern Boa *Boa imperator*

MEXICO, CENTRAL AMERICA AND SOUTH AMERICA

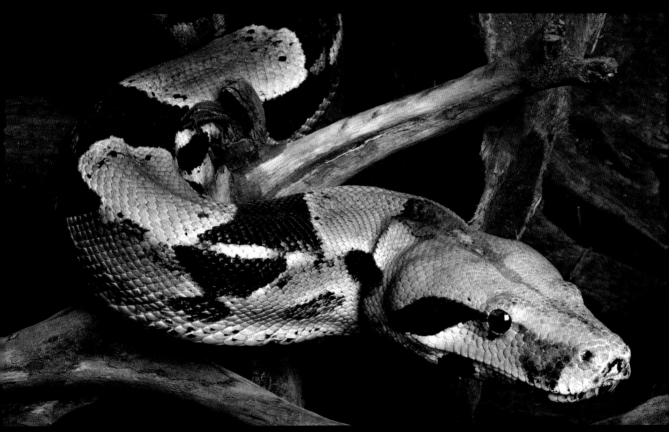

Boa Constrictor *Boa constrictor*
SOUTH AMERICA

Pacific Tree Boa *Candoia bibroni*
MELANESIA AND POLYNESIA

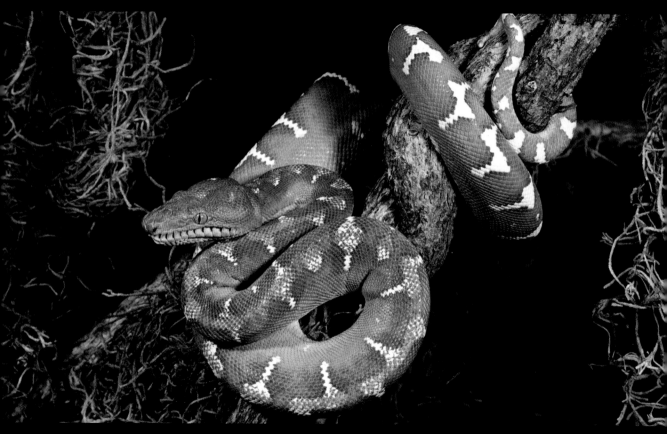

Emerald Tree Boa *Corallus caninus*

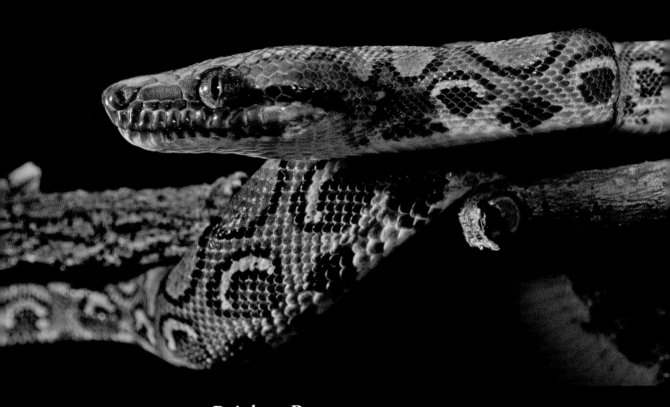

Rainbow Boa *Epicrates cenchria*
CENTRAL AMERICA AND SOUTH AMERICA

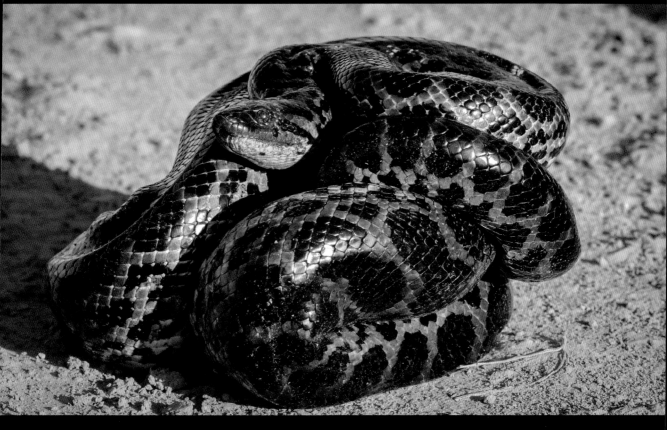

Yellow Anaconda *Eunectes notaeus*
SOUTH AMERICA

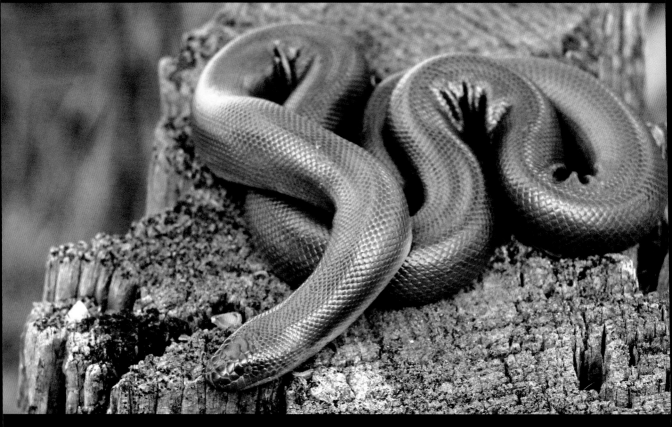

Rubber Boa *Charina bottae*

NORTH AMERICA

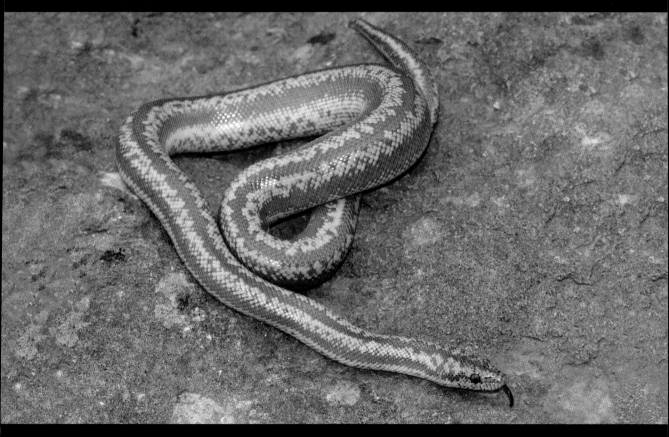

Rosy Boa *Lichanura trivirgata*
NORTH AMERICA

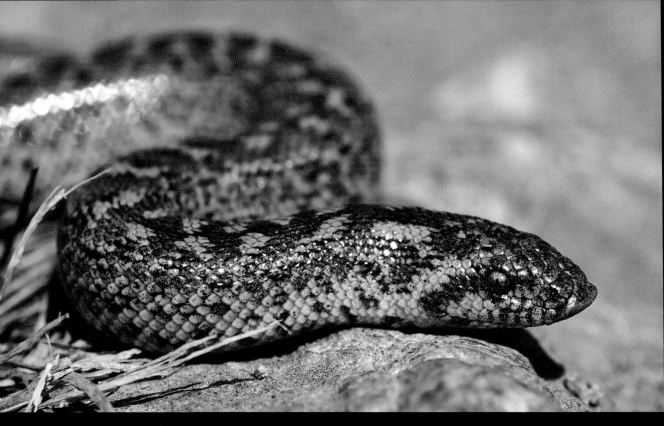

Javelin Sand Boa *Eryx jaculus*
EURASIA AND NORTH AFRICA

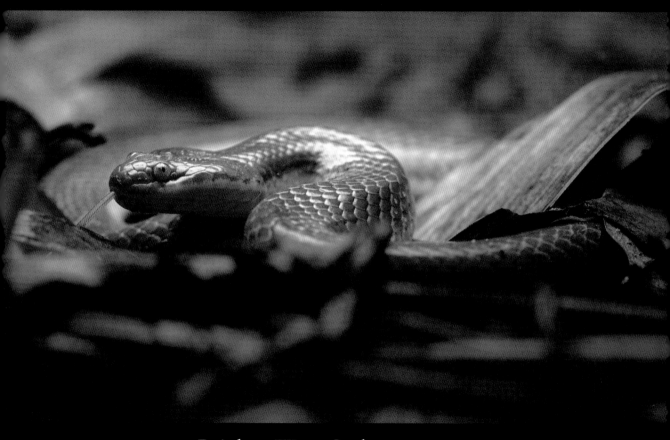

Rainbow Water Snake *Enhydris enhydris*
SOUTH ASIA

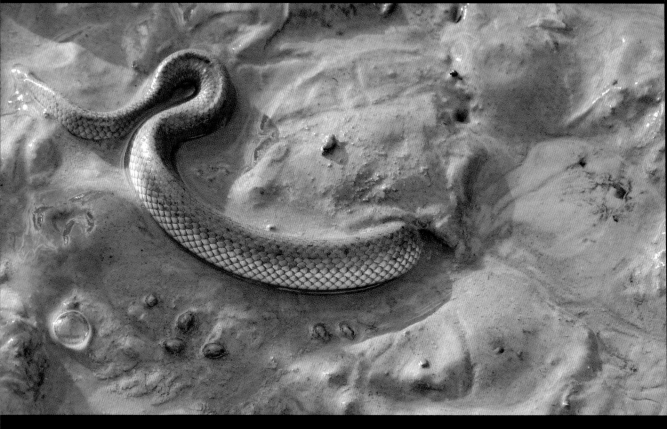

White-bellied Mangrove Snake *Fordonia leucobalia*
SOUTH ASIA AND NORTH AUSTRALIA

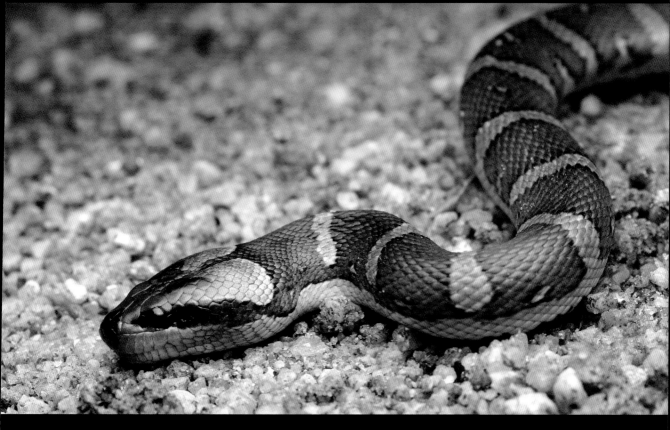

Puff-faced Water Snake *Homalopsis buccata*
SOUTH ASIA

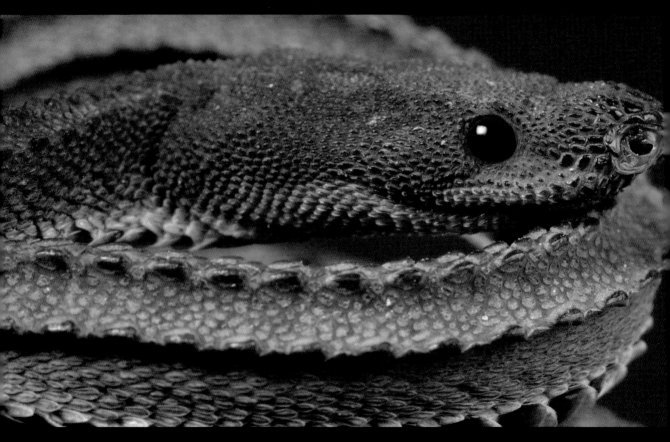

Dragon Snake *Xenodermus javanicus*
SOUTH ASIA

Perrotet's Mountain Snake *Xylophis perroteti*
INDIA

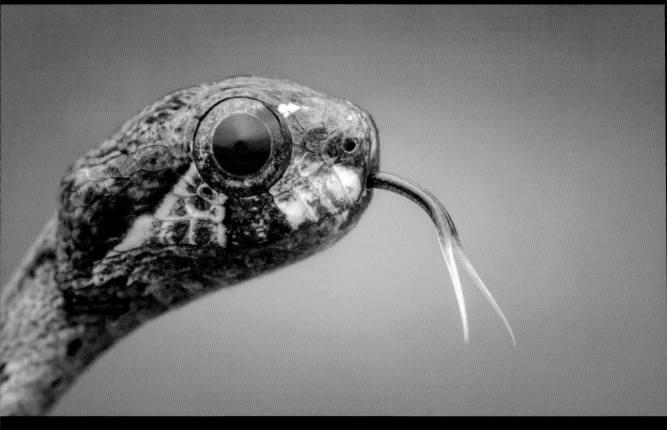

Blunt-headed Slug Snake *Aplopeltura boa*
SOUTH ASIA

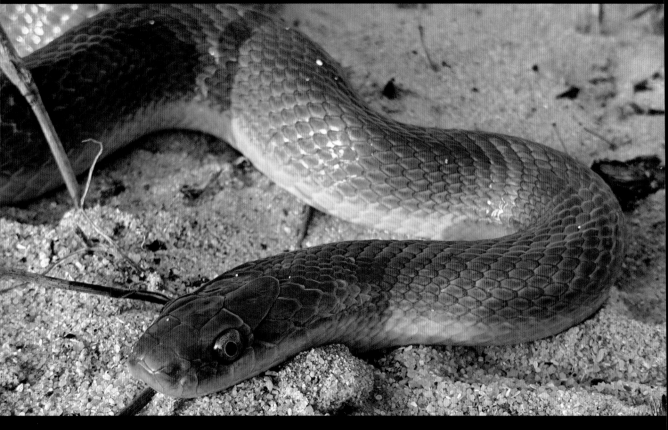

Aurora House Snake *Lamprophis aurora*

AFRICA

Brown House Snake *Lamprophis fuliginosus*
AFRICA

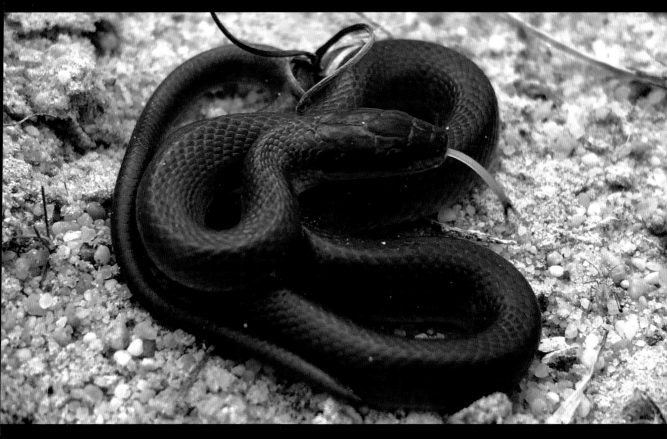

Common Brown Water Snake *Lycodonomorphus rufulus*

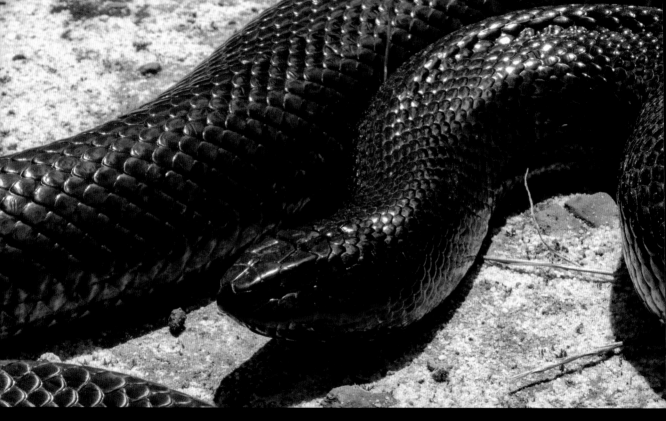

Mole Snake *Pseudaspis cana*

AFRICA

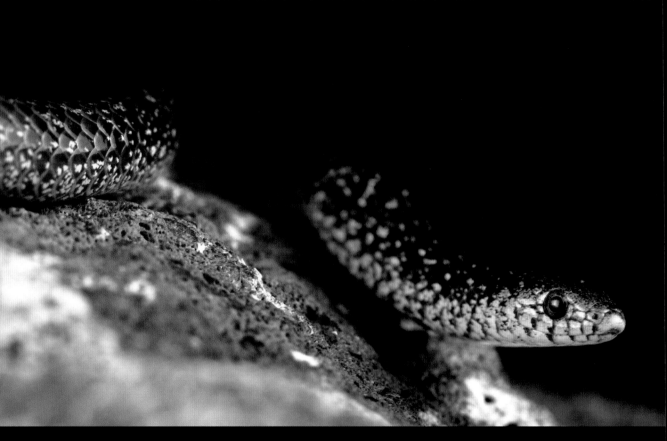

Variegated Slug-eater *Duberria variegata*
SOUTHERN AFRICA

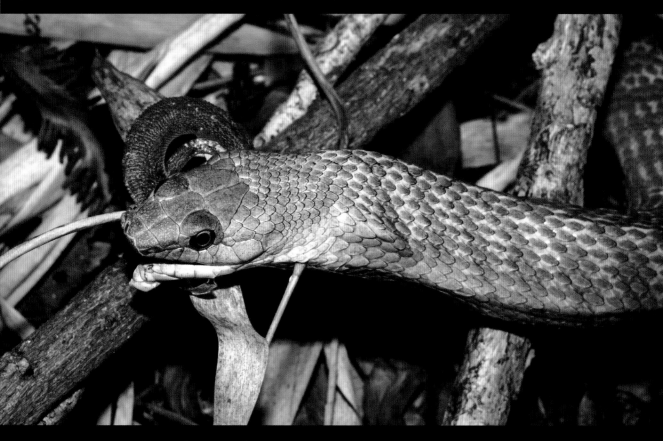

Cinnabar Malagasy Vinesnake *Ithycyphus miniatus*

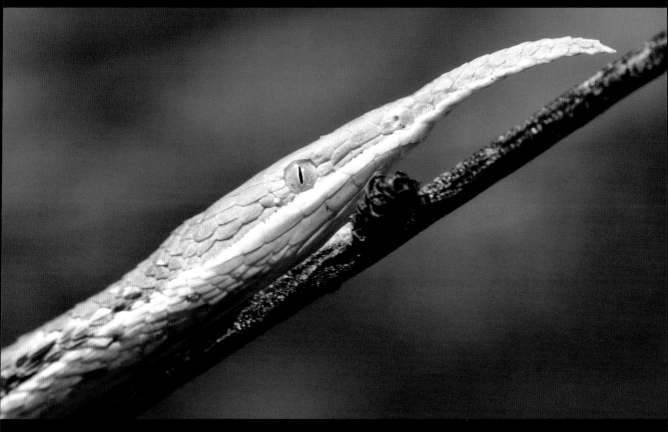

Malagasy Leaf-nosed Snake *Langaha madagascariensis*
MADAGASCAR

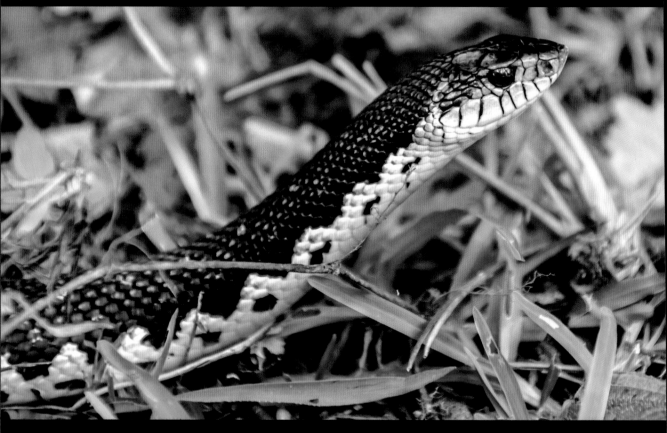

Malagasy Hog-nosed Snake *Leioheterodon madagascariensis*

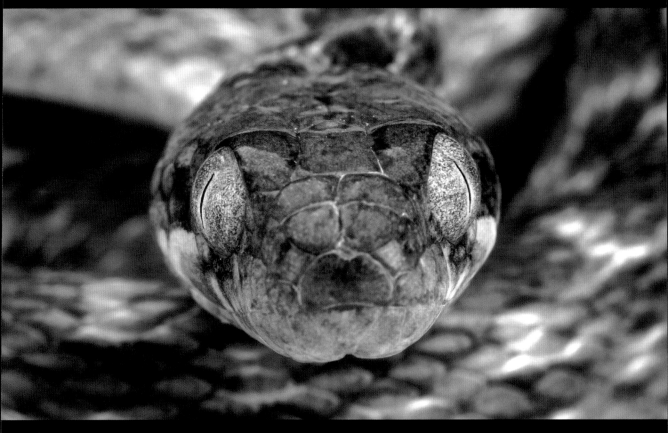

Malagasy Cat-eyed Snake *Madagascarophis meridionalis*

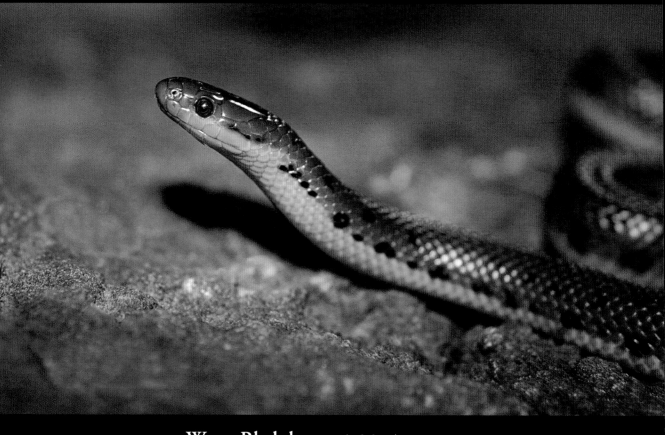

Water Rhabdops *Rhabdops aquaticus*
INDIA

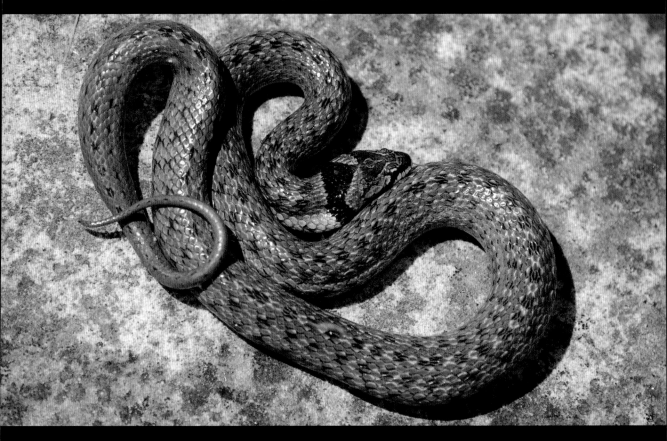

False Smooth Snake *Macroprotodon cucullatus*
MEDITERRANEAN

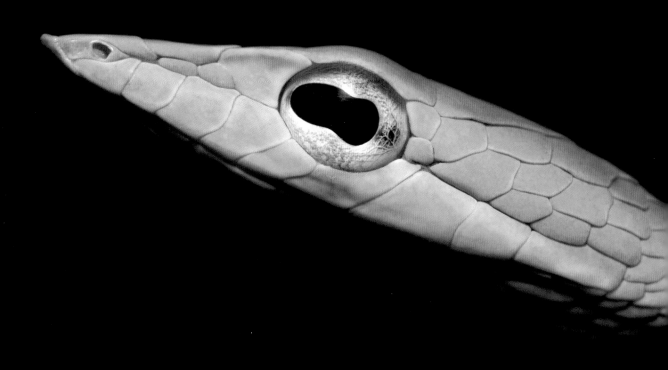

Oriental Whipsnake *Ahaetulla prasina*
SOUTH ASIA

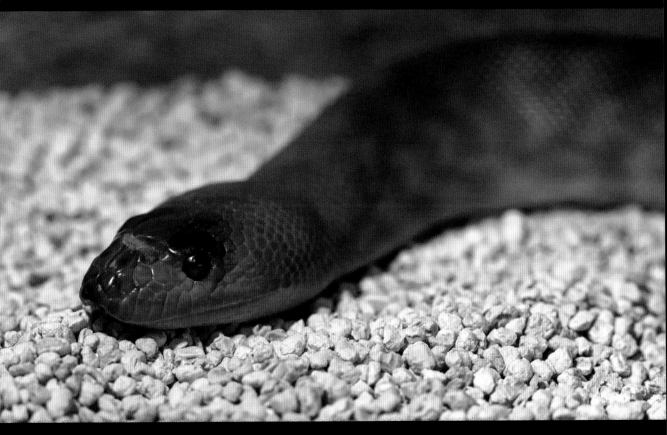

Banded Racer *Argyrogena fasciolata*

INDIAN SUBCONTINENT

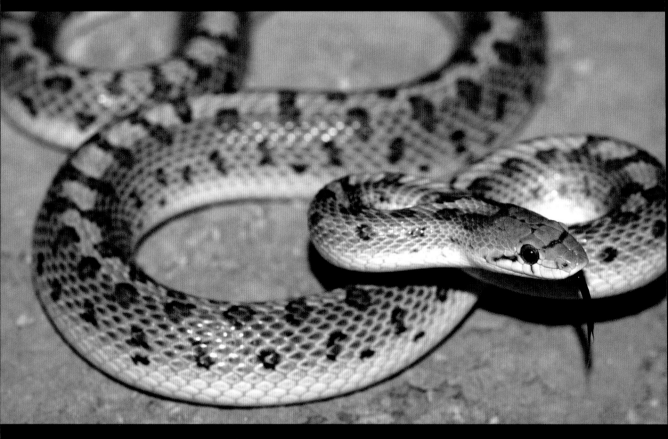

Glossy Snake *Arizona elegans*
NORTH AMERICA

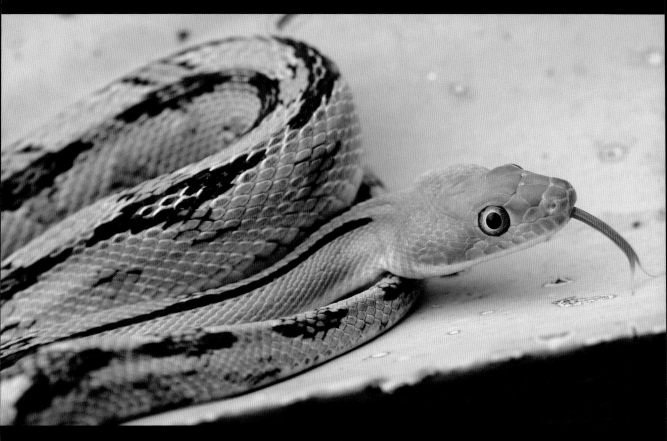

Trans-Pecos Rat Snake *Bogertophis subocularis*
NORTH AMERICA

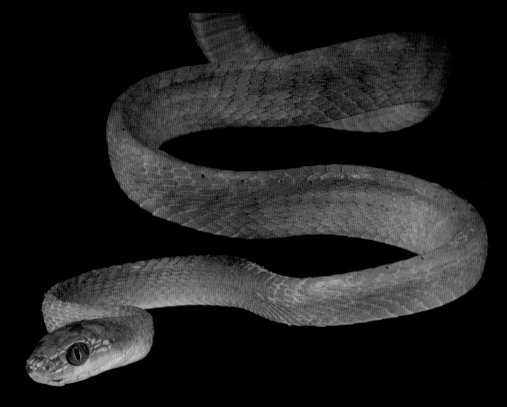

Black-headed Cat Snake *Boiga nigriceps*
SOUTH ASIA

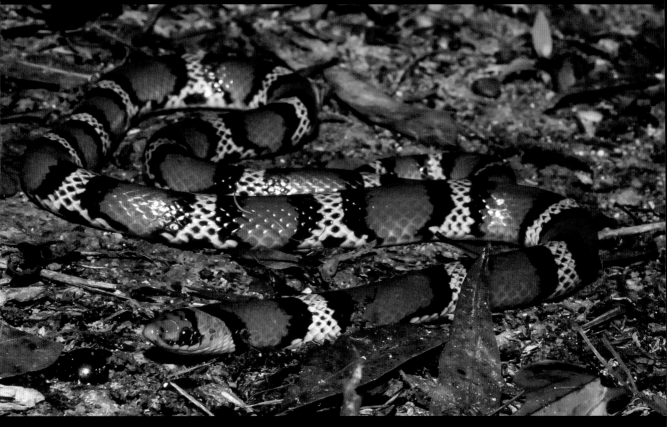

Scarlet Snake *Cemophora coccinea*
NORTH AMERICA

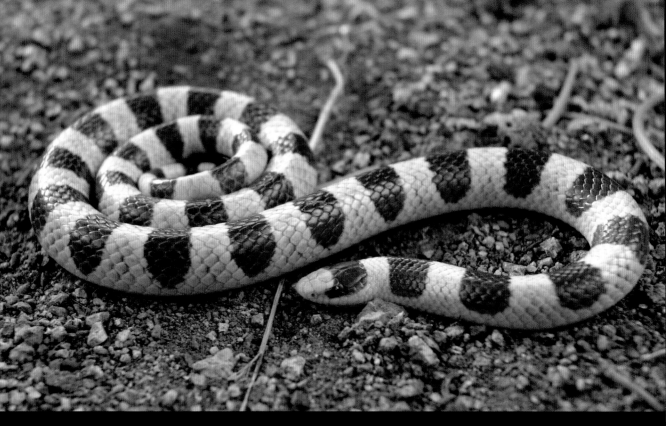

Mojave Shovel-nosed Snake *Chionactis occipitalis occipitalis*
NORTH AMERICA

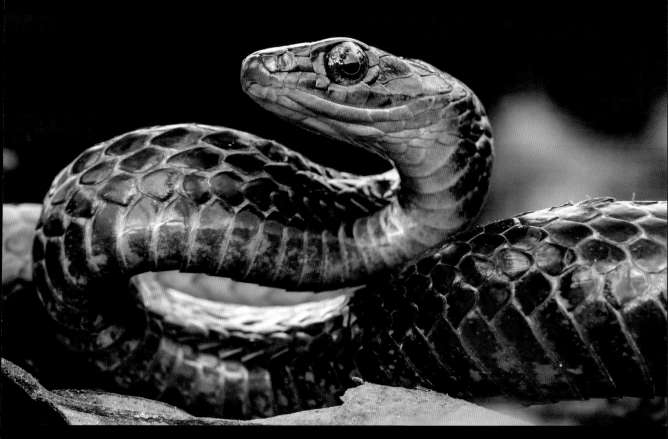

Wagler's Sipo *Chironius scurrulus*
SOUTH AMERICA

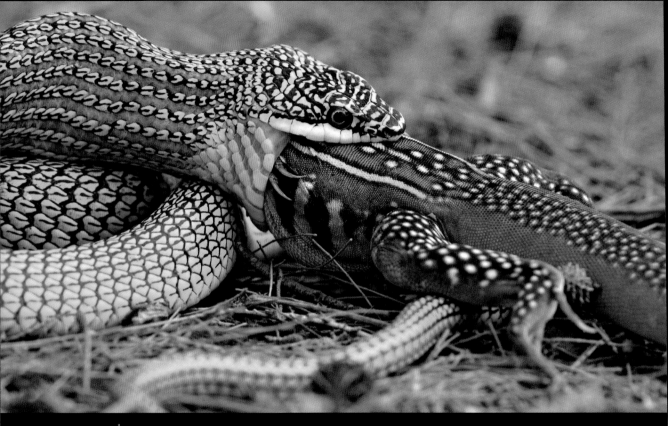

Golden Tree Snake *Chrysopelea ornata*
SOUTH ASIA

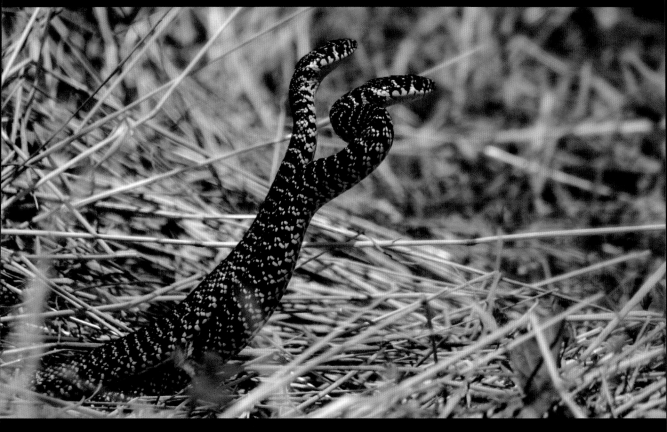

Western Whipsnake *Hierophis viridiflavus*
SOUTHERN EUROPE

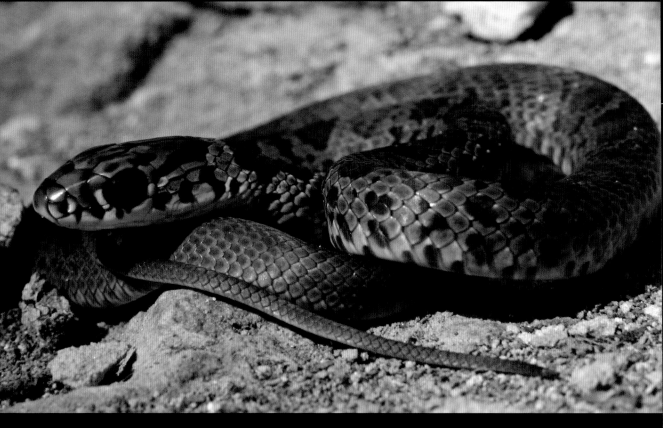

Southern Black Racer *Coluber constrictor priapus*
NORTH AMERICA

Smooth Snake *Coronella austriaca*

EURASIA

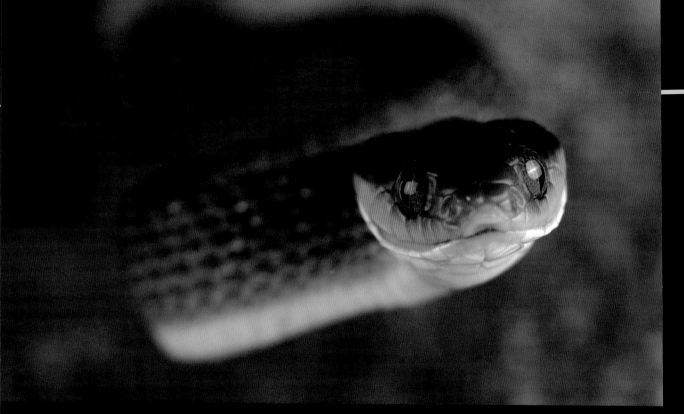

Red-lipped Snake *Crotaphopeltis hotamboeia*
AFRICA

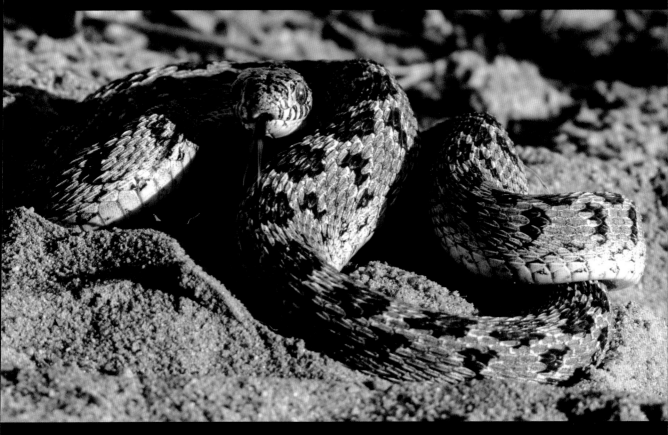

Rhombic Egg-eater *Dasypeltis scabra*

AFRICA AND ARABIA

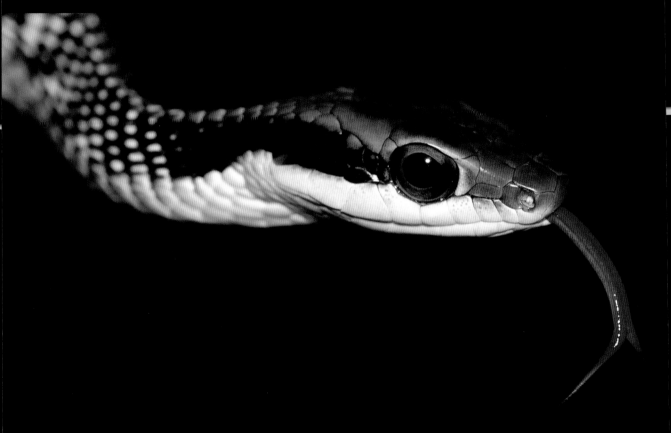

Nganson Bronzeback *Dendrelaphis ngansonensis*
SOUTH ASIA

South American Forest Racer *Dendrophidion percarinatum*

CENTRAL AMERICA AND SOUTH AMERICA

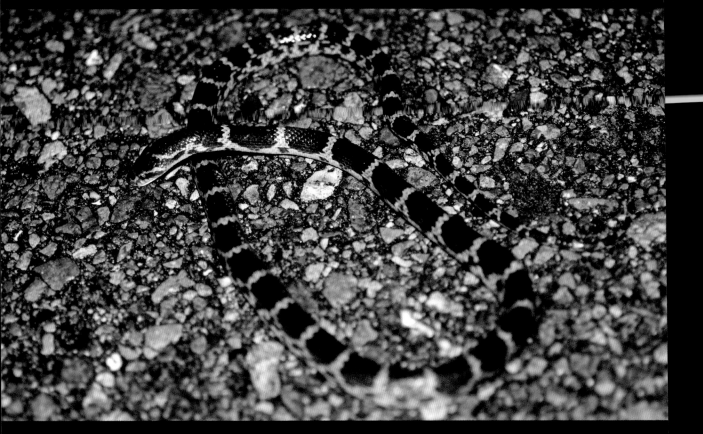

Red-banded Snake or **Sakishima Odd-tooth Snake** *Dinodon rufozomatus walli*
JAPAN

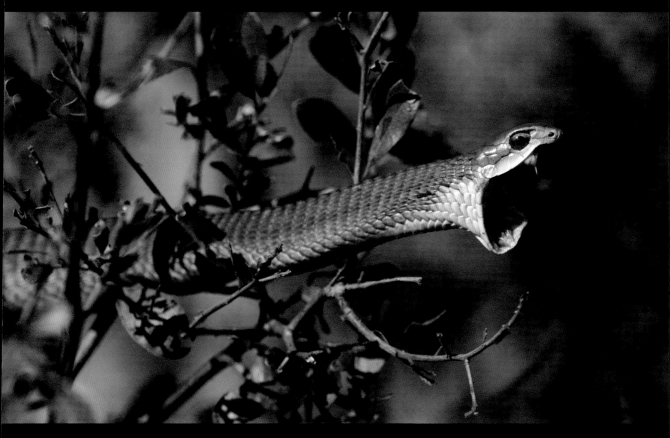

Boomslang *Dispholidus typus*
AFRICA

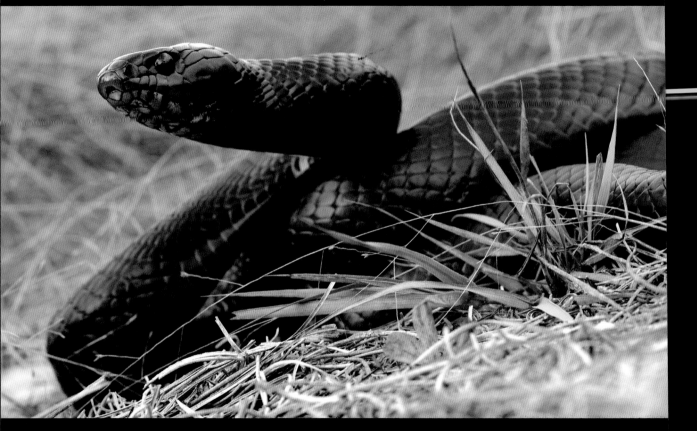

Eastern Indigo Snake *Drymarchon couperi*
NORTH AMERICA

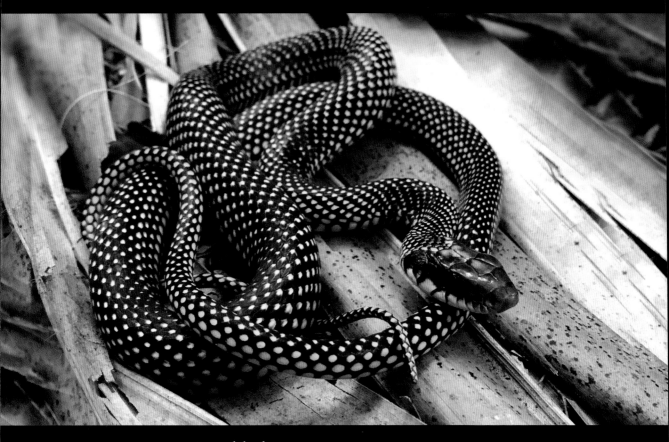

Speckled Racer *Drymobius margaritiferus*
NORTH AMERICA AND CENTRAL AMERICA

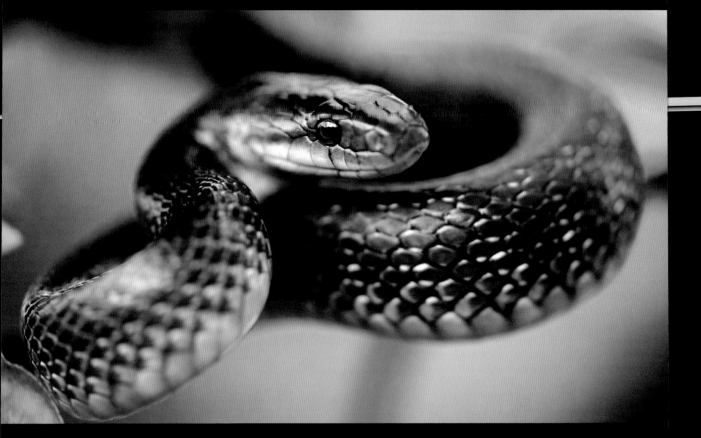

Aesculapian Snake *Zamenis longissimus*

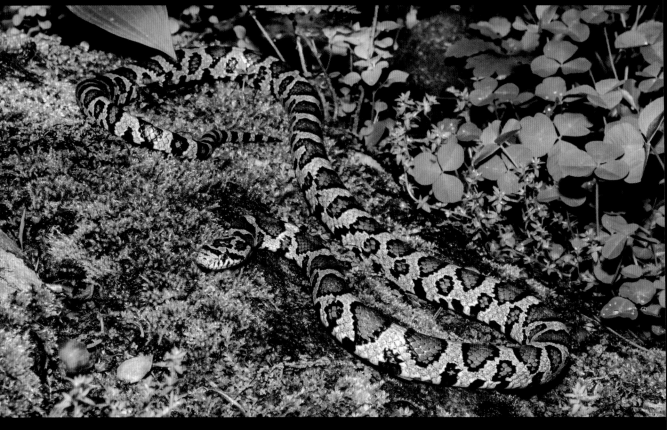

Eastern Milksnake *Lampropeltis triangulum*
NORTH AMERICA

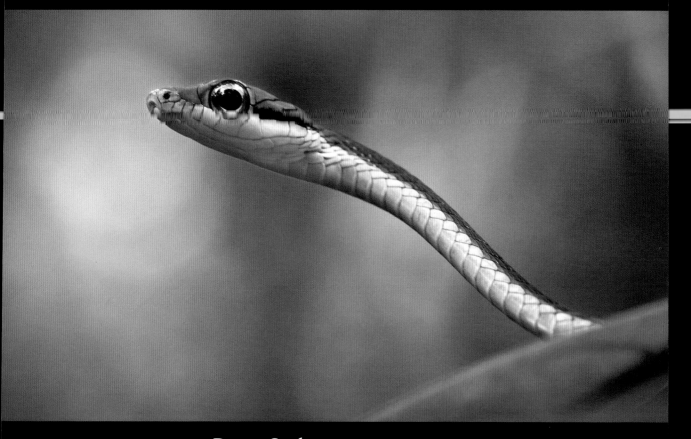

Parrot Snake *Leptophis ahaetulla*

CENTRAL AMERICA AND SOUTH AMERICA

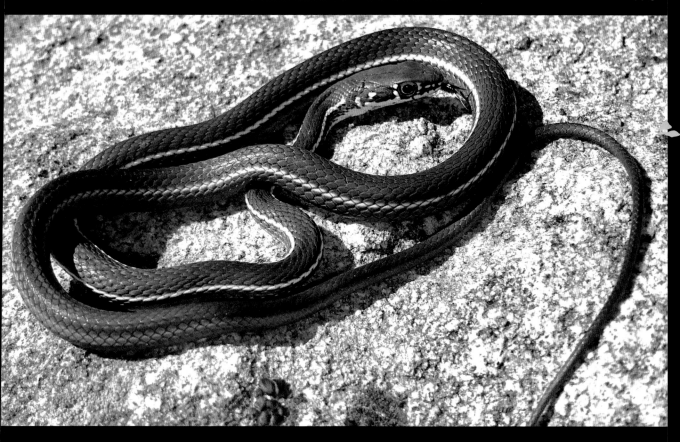

Striped Racer *Masticophis lateralis*
NORTH AMERICA

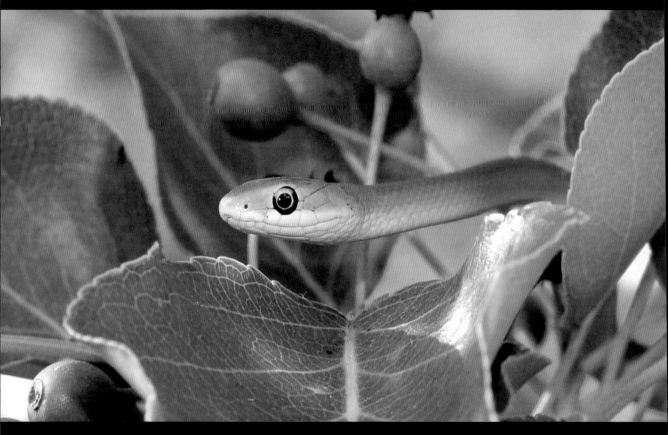

Rough Green Snake *Opheodrys aestivus*

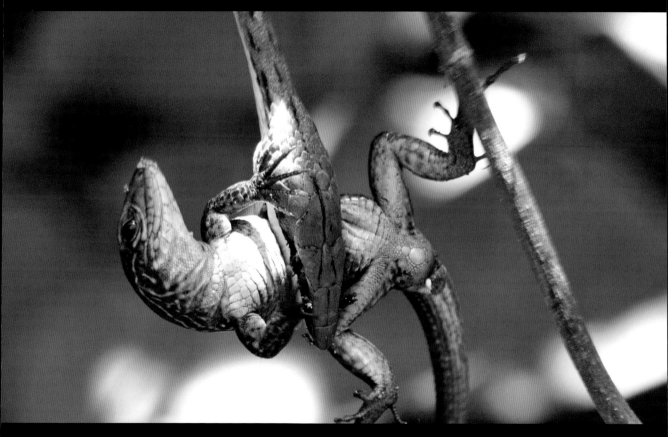

Brown Vinesnake *Oxybelis aeneus*

AMERICAS

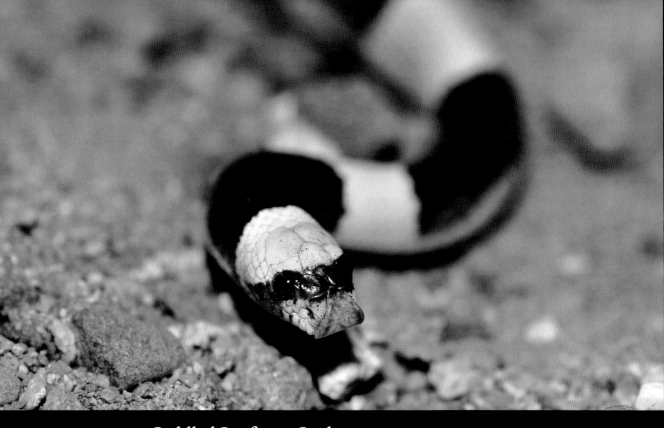

Saddled Leafnose Snake *Phyllorhynchus browni*
NORTH AMERICA

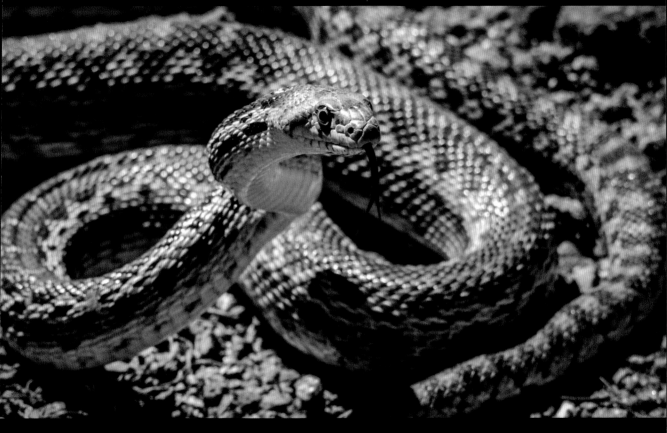

Pacific Gopher Snake *Pituophis catenifer*
NORTH AMERICA

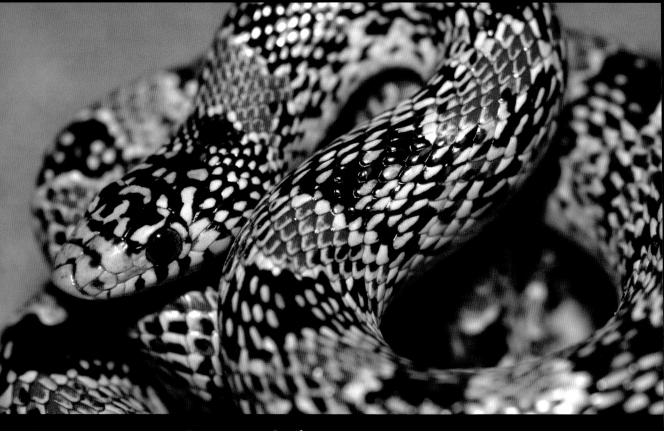

Longnose Snake　*Rhinocheilus lecontei*

NORTH AMERICA

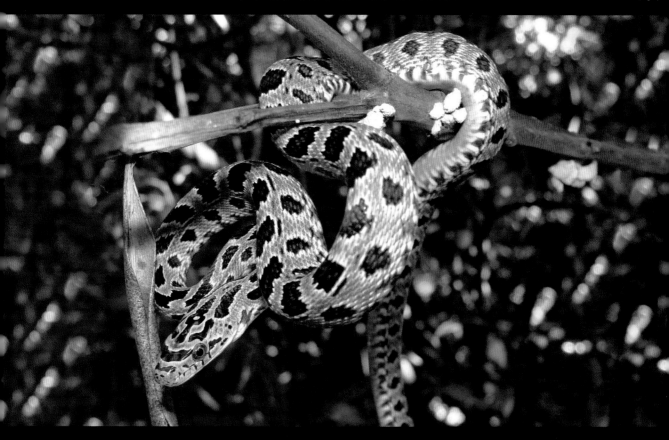

Peninsular (Green) Rat Snake *Senticolis triaspis*
NORTH AMERICA AND CENTRAL AMERICA

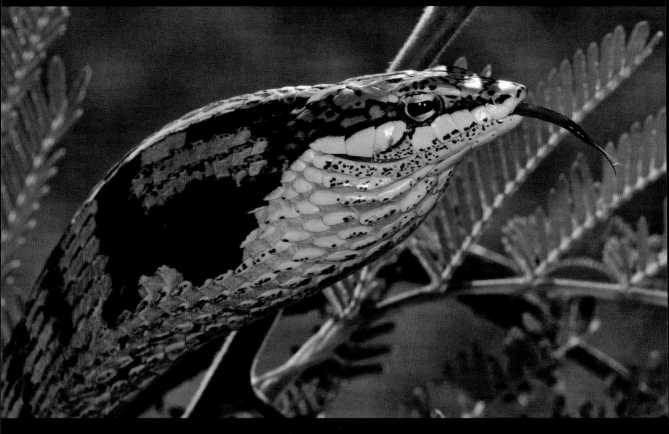

Twig Snake *Thelotornis capensis*
AFRICA

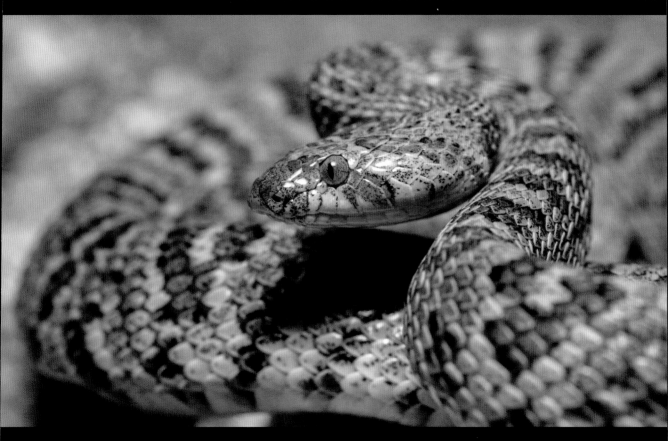

California Lyre Snake *Trimorphodon lyrophanes*

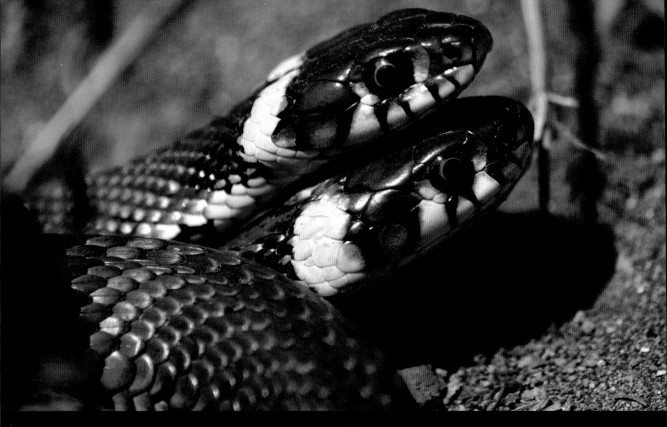

European Grass Snake *Natrix natrix*

Red-sided Garter Snake *Thamnophis sirtalis parietalis*
NORTH AMERICA

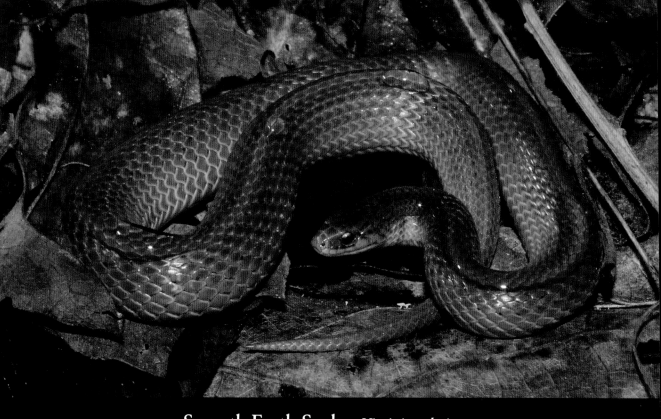

Smooth Earth Snake *Virginia valeriae*
NORTH AMERICA

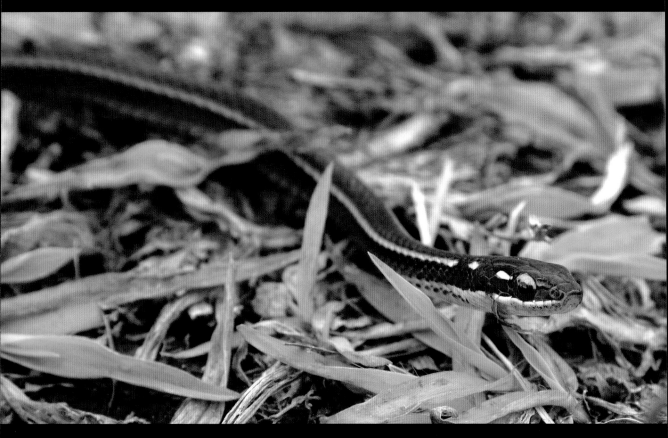

Cope's Black-striped Snake *Coniophanes piceivittis*

Night Snake *Hypsiglena torquata*
MEXICO

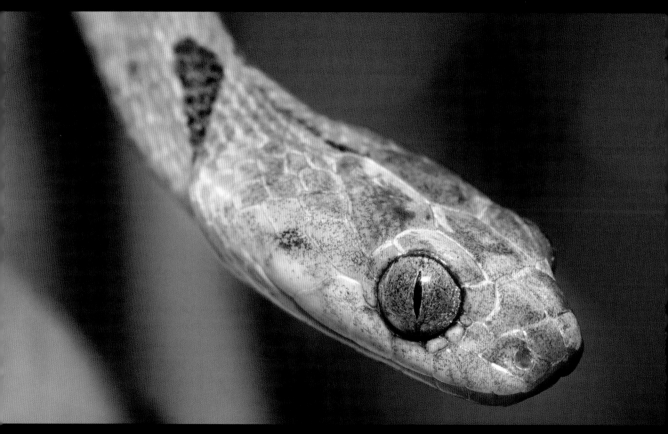

Northern Cat-eyed Snake *Leptodeira septentrionalis*
CENTRAL AMERICA AND SOUTH AMERICA

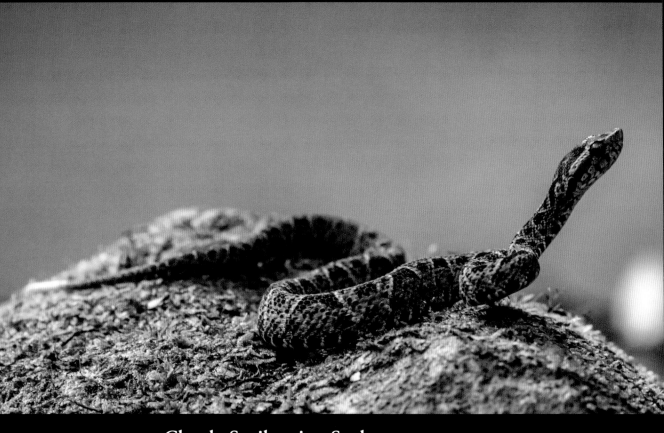

Cloudy Snail-eating Snake *Sibon nebulatus*
SOUTH AMERICA

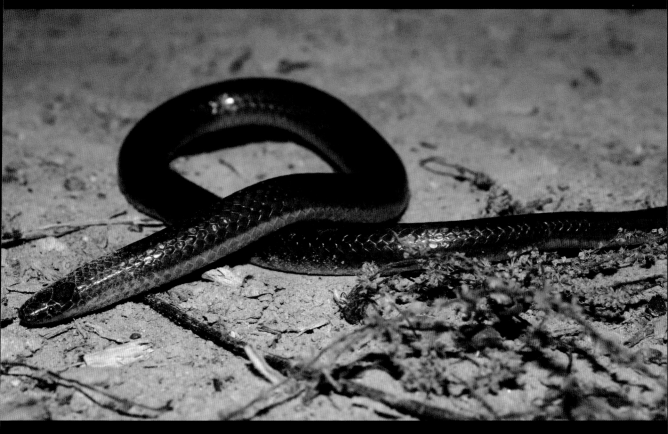

Eastern Wormsnake *Carphophis amoenus*
NORTH AMERICA

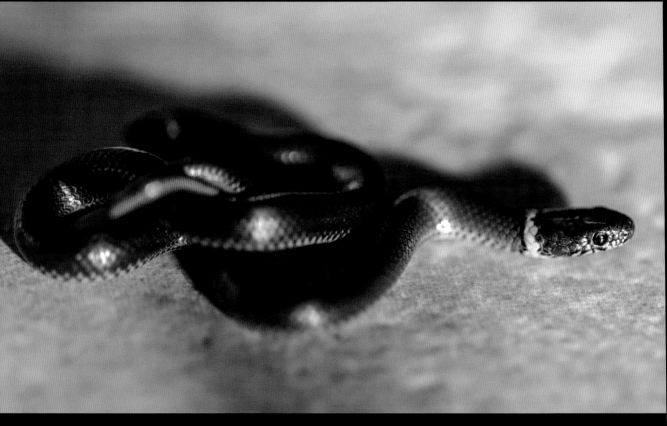

Pacific Ringneck Snake *Diadophis punctatus amabilis*
NORTH AMERICA

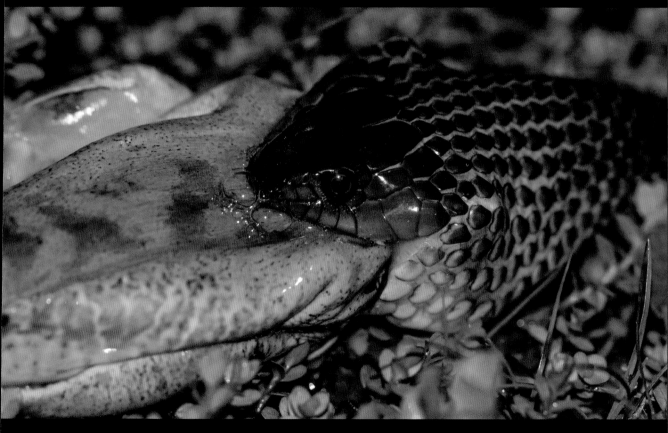

Military Ground Snake *Erythrolamprus miliaris*
SOUTH AMERICA

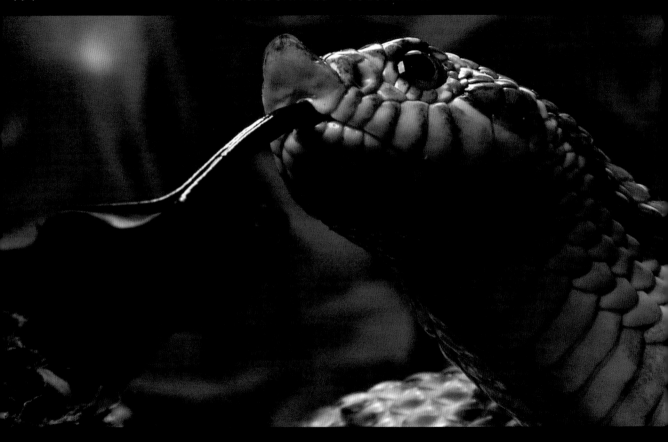

Western Hognose Snake *Heterodon nasicus*
NORTH AMERICA

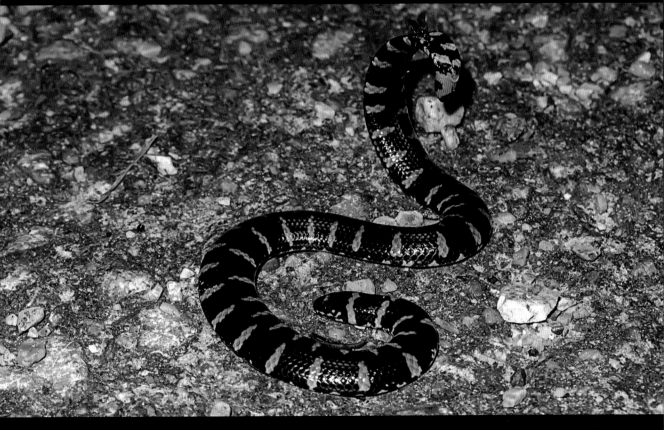

Red-tailed Pipe Snake *Cylindrophis ruffus*
SOUTH ASIA

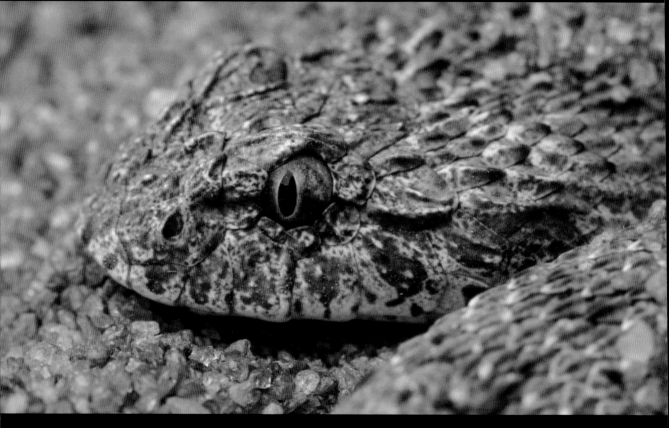

Desert Death Adder *Acanthophis pyrrhus*
AUSTRALIA

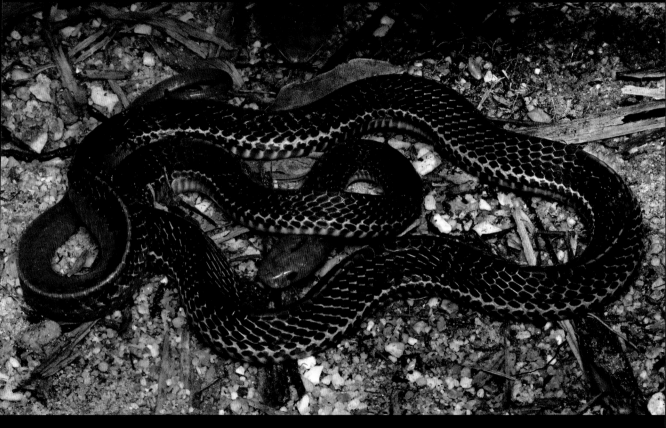

Red-headed Krait *Bungarus flaviceps*
SOUTH ASIA

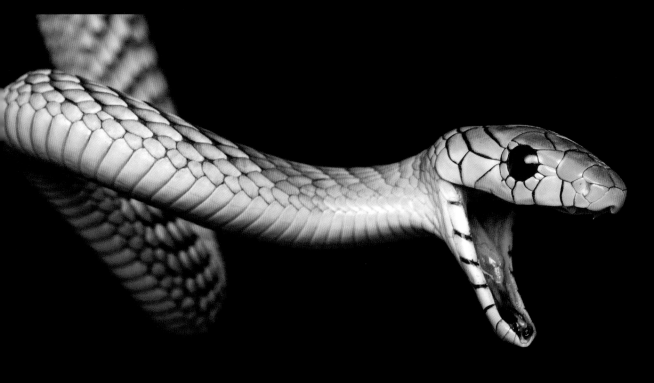

Western Green Mamba *Dendroaspis viridis*
WEST AFRICA

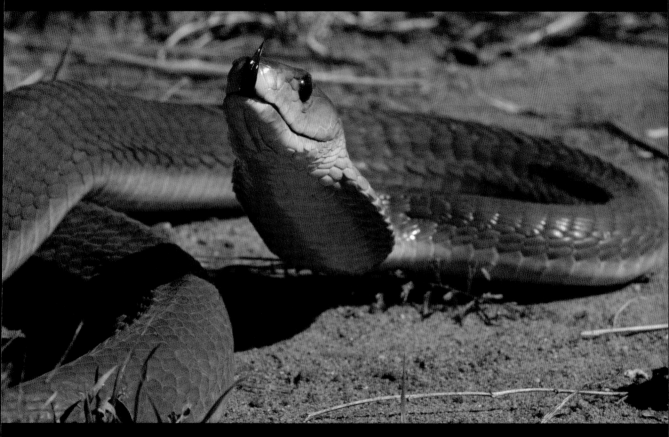

Black Mamba *Dendroaspis polylepis*

AFRICA

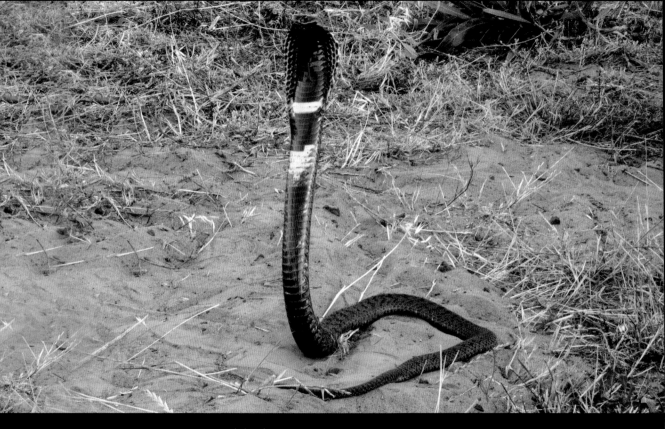

Rinkhals *Hemachatus haemachatus*

SOUTHERN AFRICA

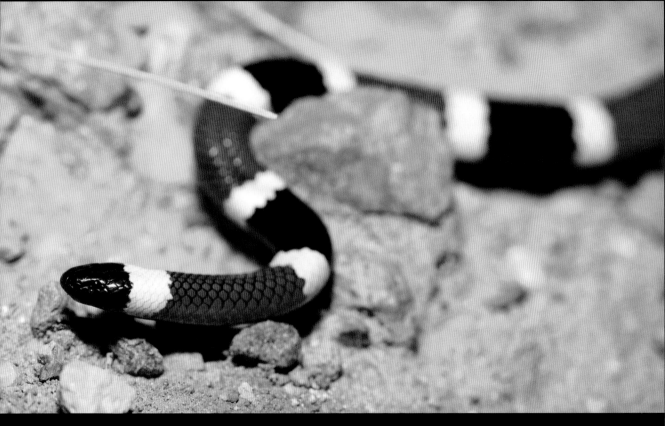

Sonoran Coral Snake *Micruroides euryxanthus*
NORTH AMERICA

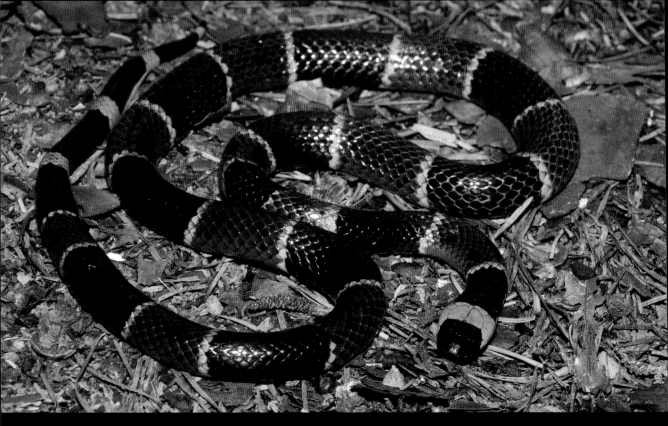

Eastern Coral Snake *Micrurus fulvius*
NORTH AMERICA

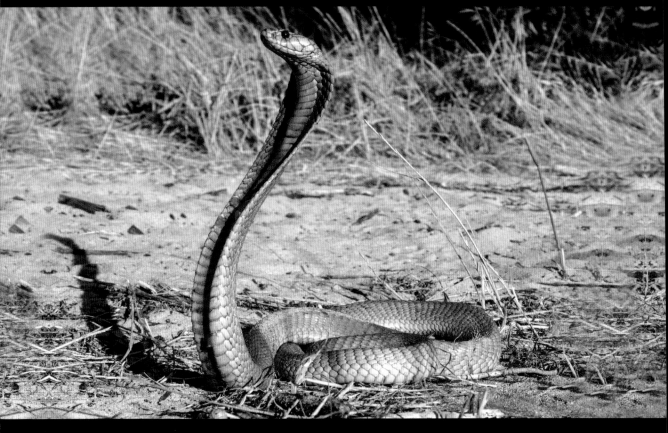

Cape Cobra *Naja nivea*
AFRICA

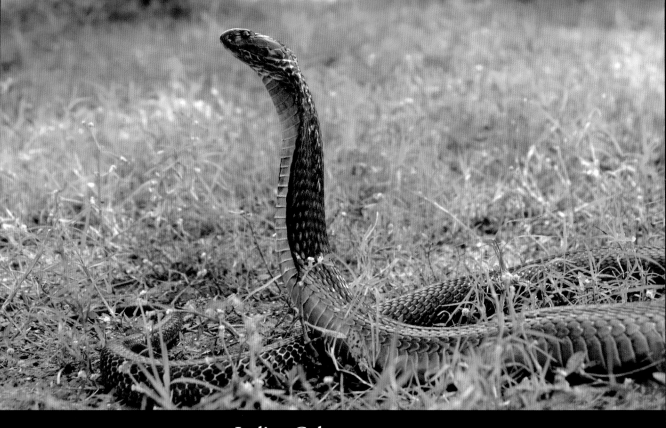

Indian Cobra *Naja naja*
INDIAN SUBCONTINENT

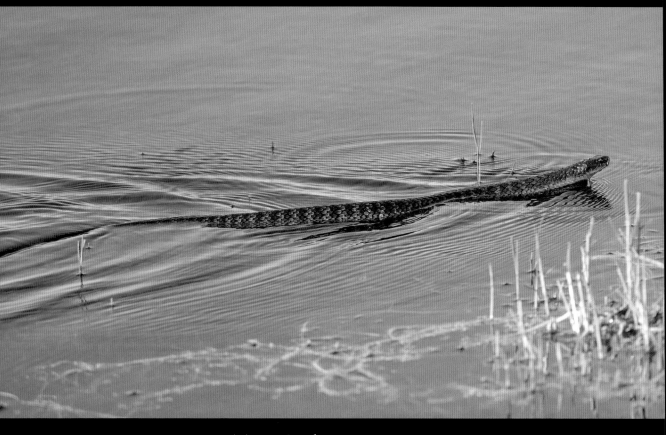

Tiger Snake *Notechis scutatus*

AUSTRALIA

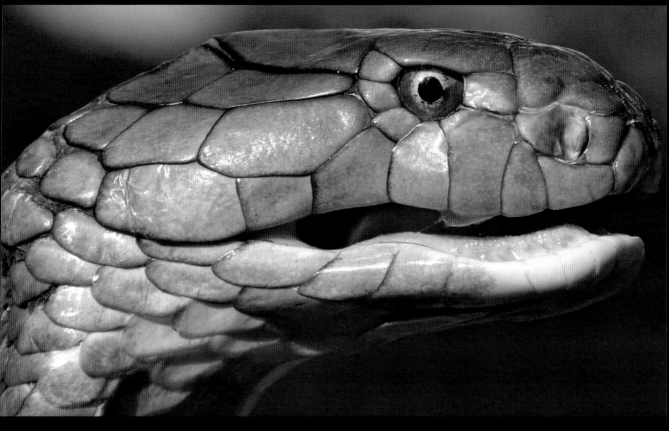

King Cobra *Ophiophagus hannah*

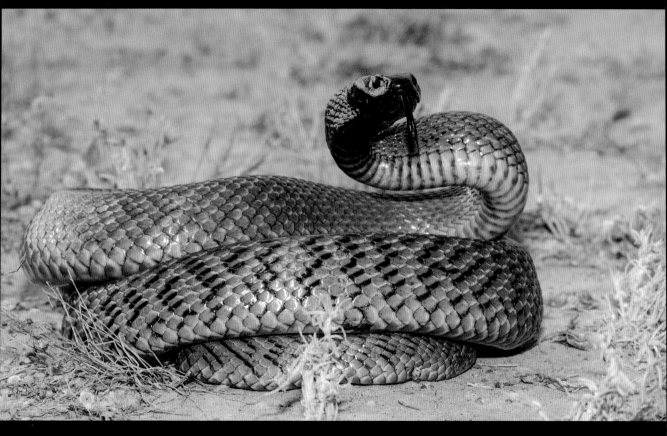

Inland Taipan *Oxyuranus microlepidotus*
AUSTRALIA

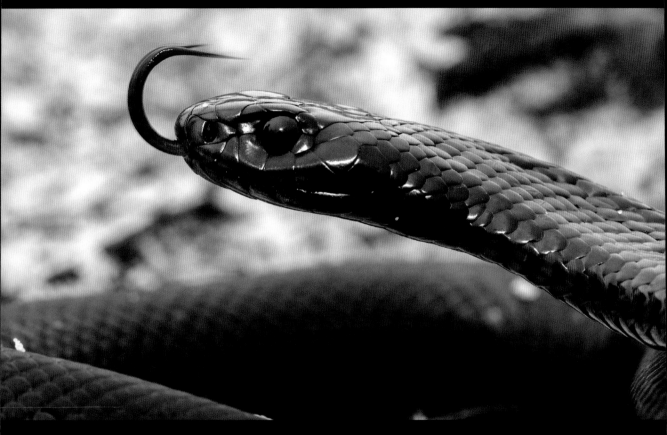

Red-bellied Black Snake *Pseudechis porphyriacus*
AUSTRALIA

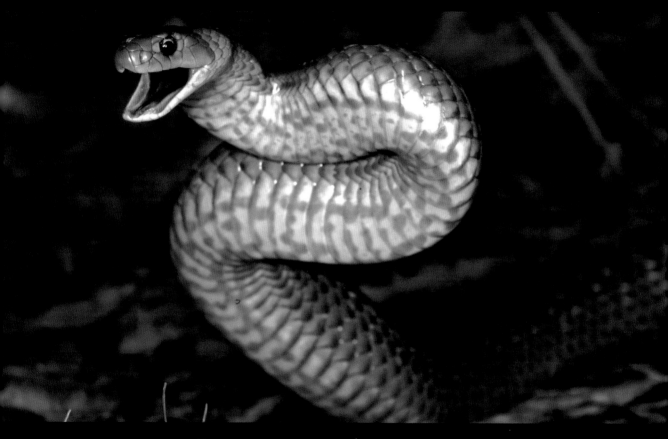

Eastern Brown Snake *Pseudonaja textilis*
AUSTRALIA

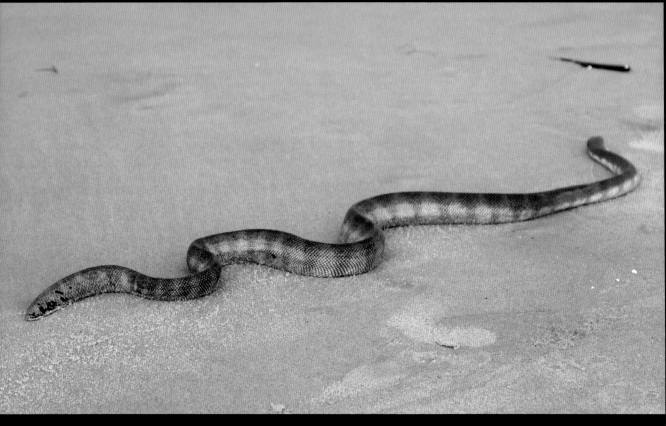

Hook-nosed Sea Snake *Hydrophis schistosus*

SEAS OFF SOUTH ASIA AND AUSTRALIA

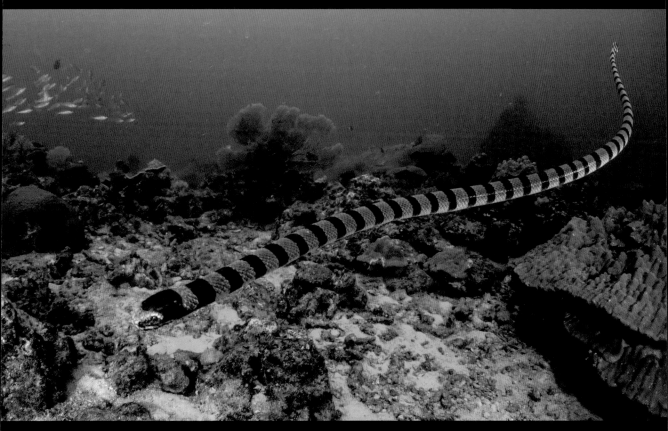

Yellow-lipped Sea Krait *Laticauda colubrina*
INDIAN OCEAN AND PACIFIC OCEAN

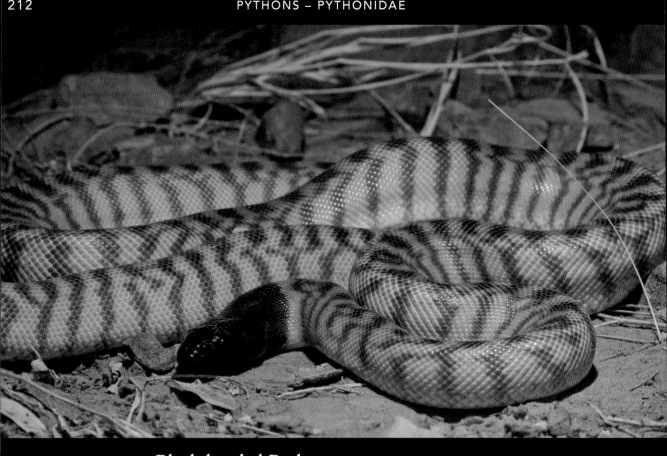

Black-headed Python *Aspidites melanocephalus*

Jungle Carpet Python *Morelia spilota cheynei*
AUSTRALIA

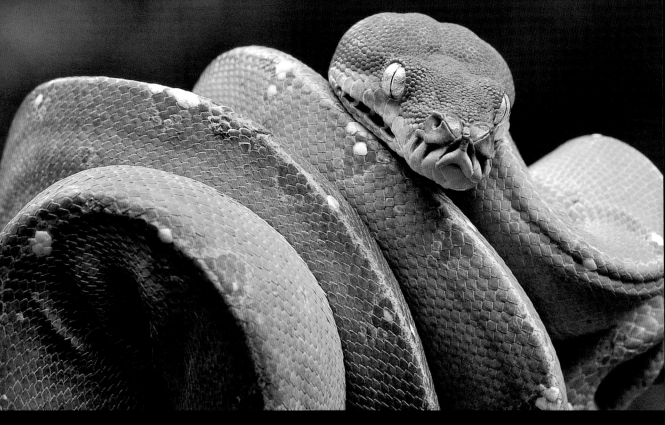

Green Tree Python *Morelia viridis*

INDONESIA, NEW GUINEA AND AUSTRALIA

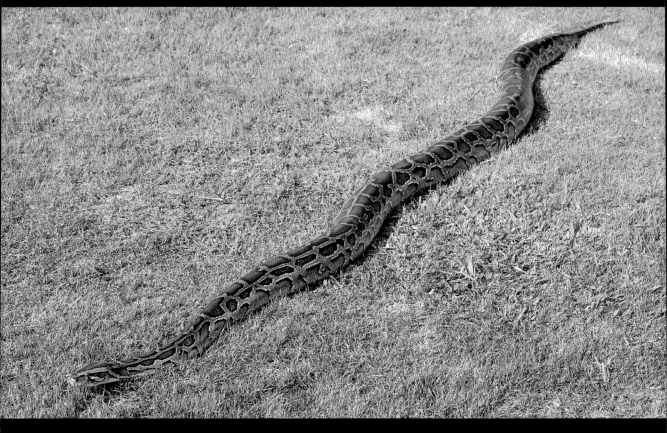

Reticulated Python *Malayopython reticulatus*

SOUTH-EAST ASIA

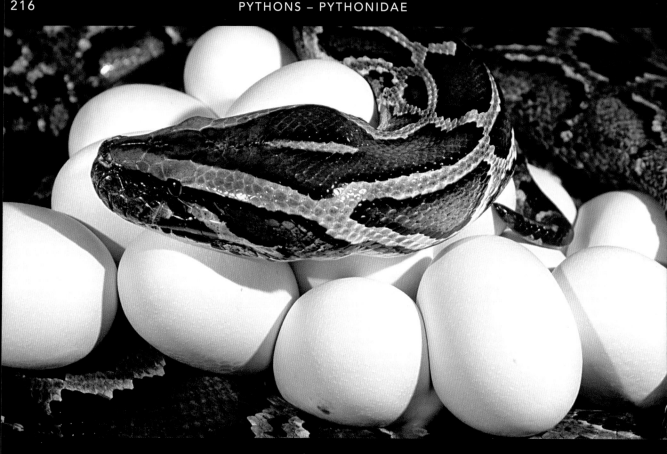

Burmese Python *Python bivittatus*
SOUTH ASIA

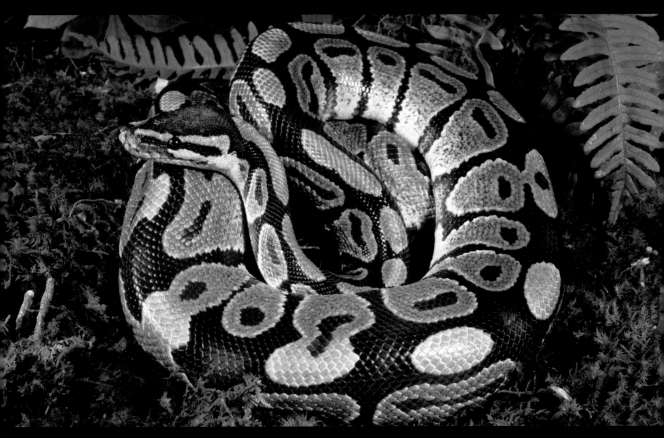

Royal Python or **Ball Python** *Python regius*
AFRICA

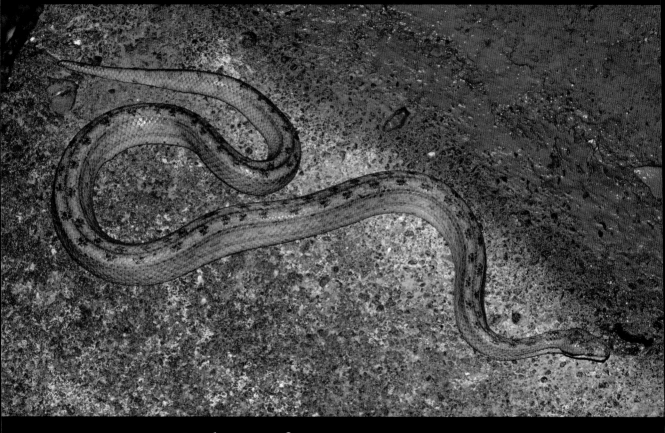

Dusky Dwarf Boa *Tropidophis melanurus*
CUBA

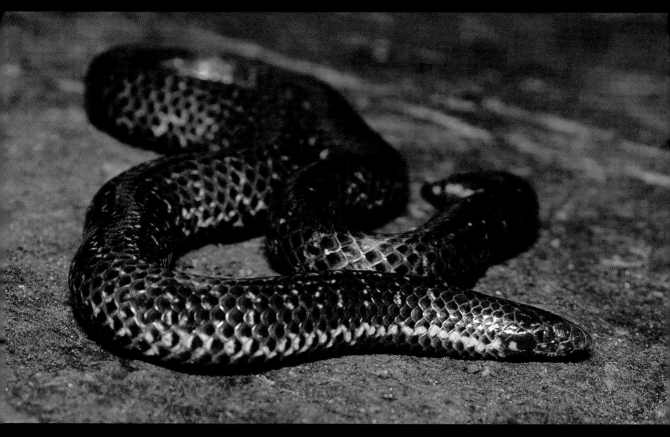

Elliot's Shieldtail *Uropeltis ellioti*
INDIA

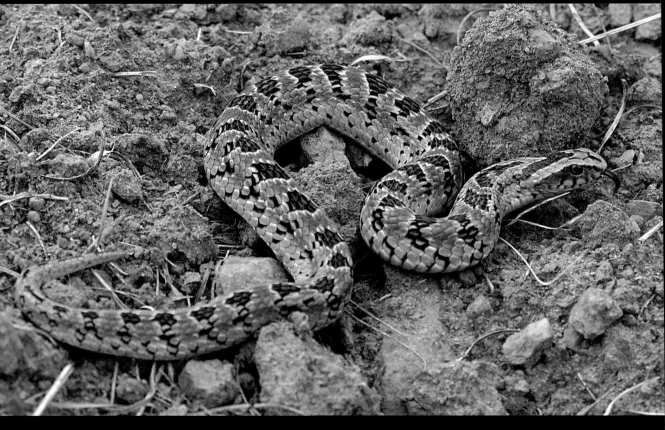

Common Night Adder *Causus rhombeatus*
AFRICA

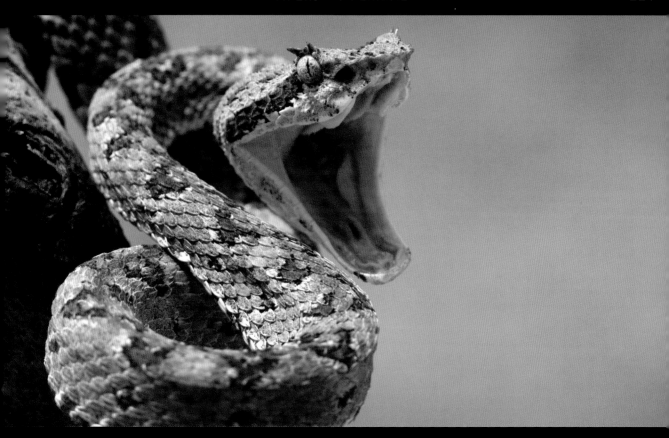

Eyelash Viper *Bothriechis schlegelii*
CENTRAL AMERICA AND SOUTH AMERICA

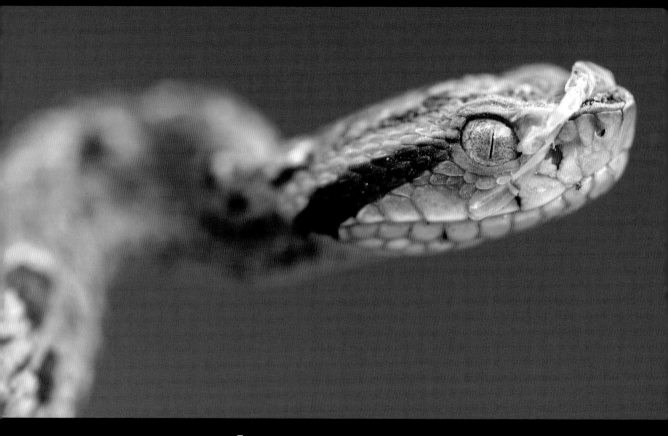

Jararaca *Bothrops jararaca*
SOUTH AMERICA

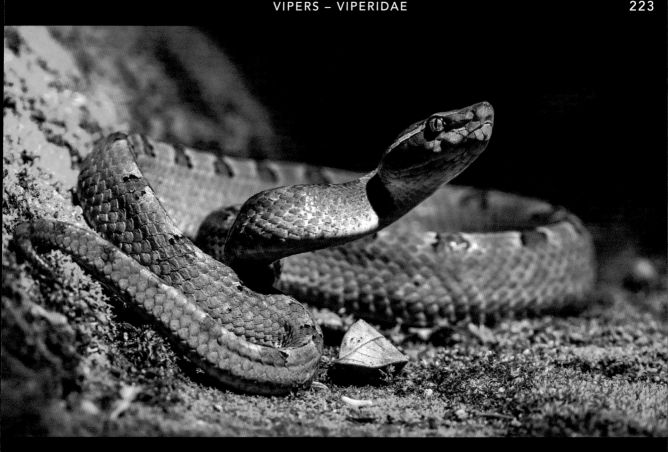

Malayan Pit Viper *Calloselasma rhodostoma*
SOUTH-EAST ASIA

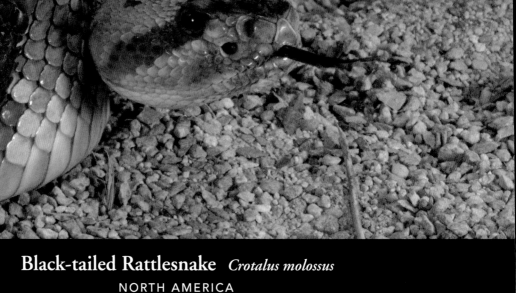

Black-tailed Rattlesnake *Crotalus molossus*
NORTH AMERICA

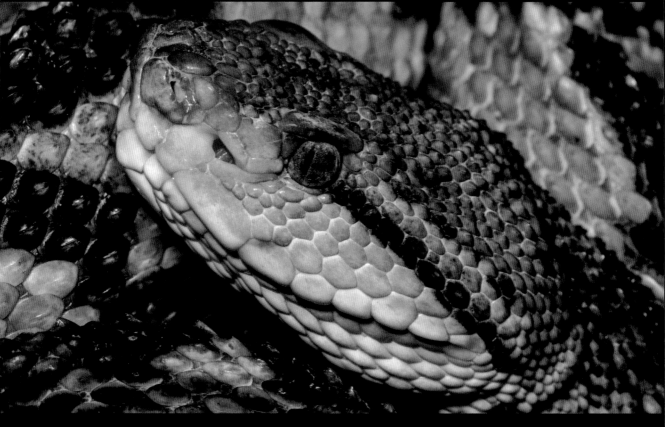

Bushmaster *Lachesis muta*
SOUTH AMERICA

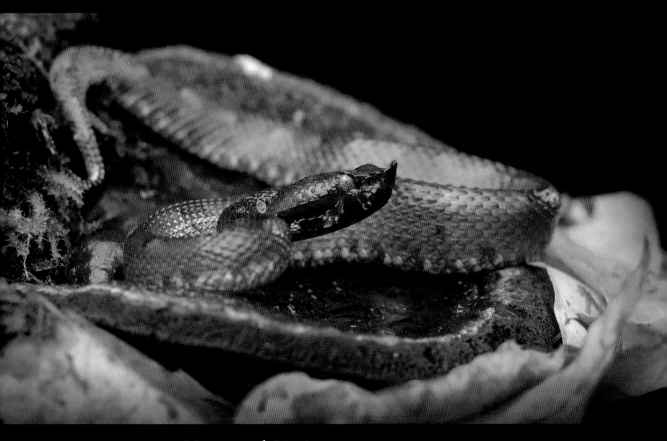

Hognosed Pitviper *Porthidium nasutum*
CENTRAL AMERICA AND SOUTH AMERICA

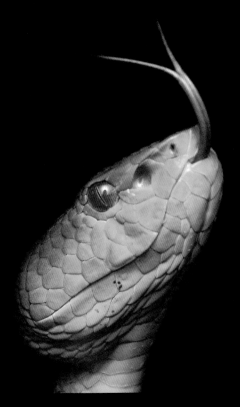

Sabah Bamboo Pitviper *Trimeresurus sabahi*
SOUTH-EAST ASIA

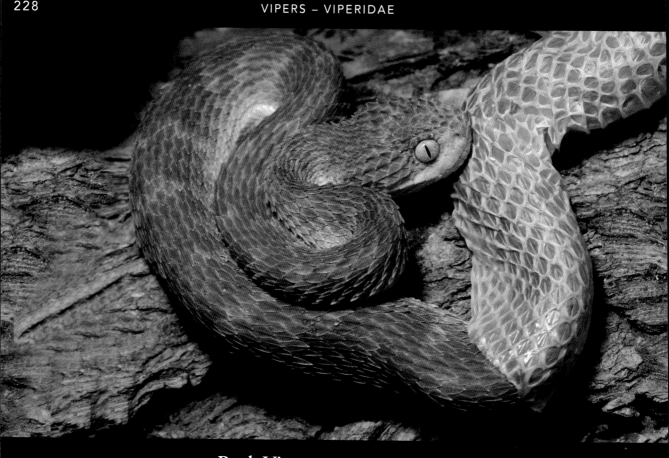

Bush Viper *Atheris squamigera*

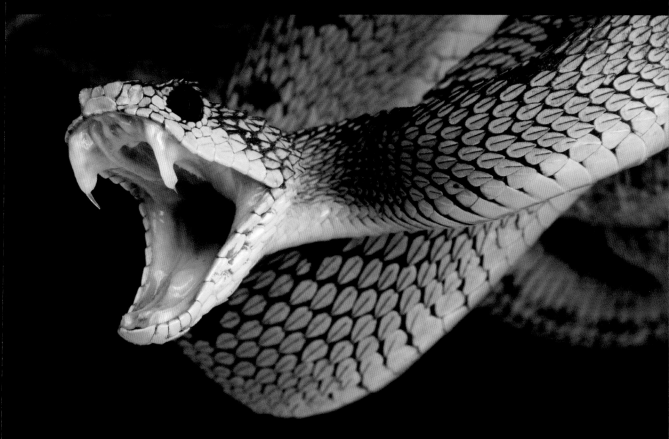

Great Lakes Bush Viper *Atheris nitschei*
AFRICA

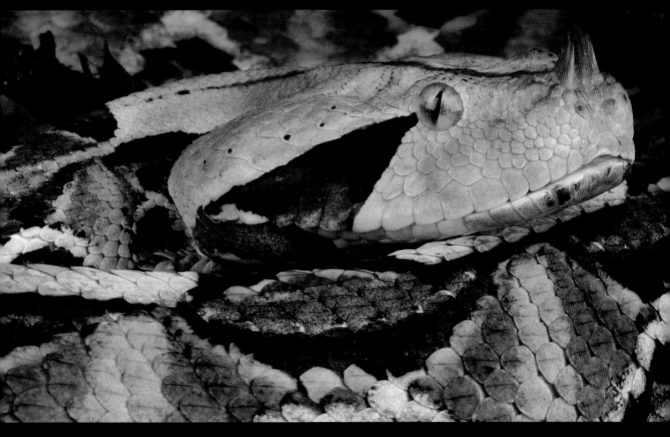

Gaboon Viper *Bitis rhinoceros*
AFRICA

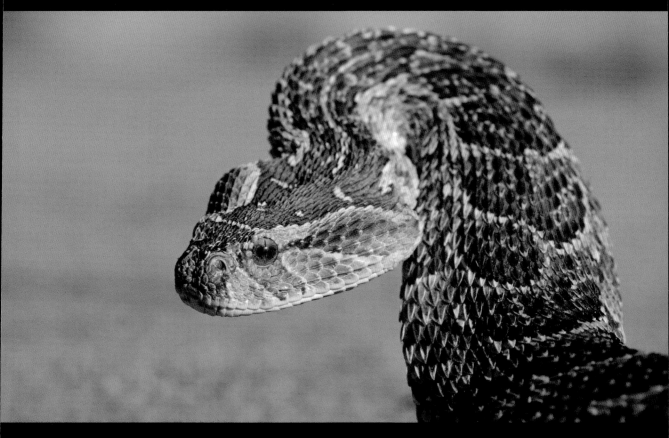

Puff Adder *Bitis arietans*
AFRICA

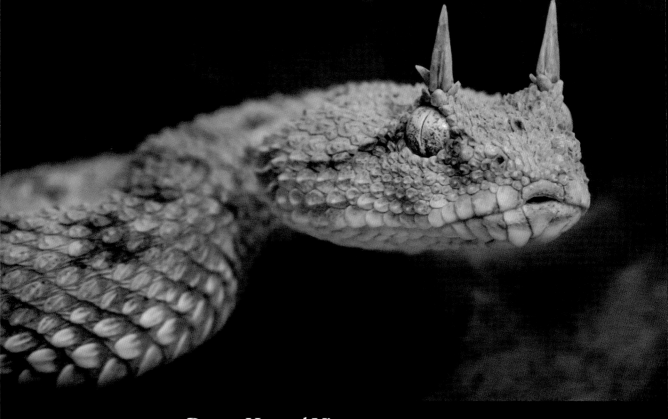

Desert Horned Viper *Cerastes cerastes*

AFRICA AND ARABIA

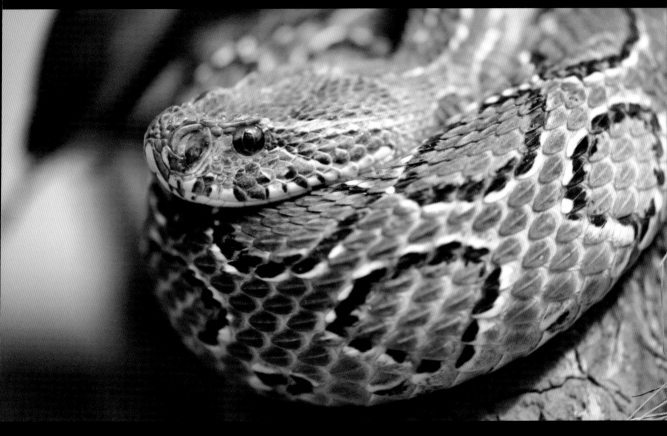

Russell's Viper *Daboia russelii*
INDIAN SUBCONTINENT

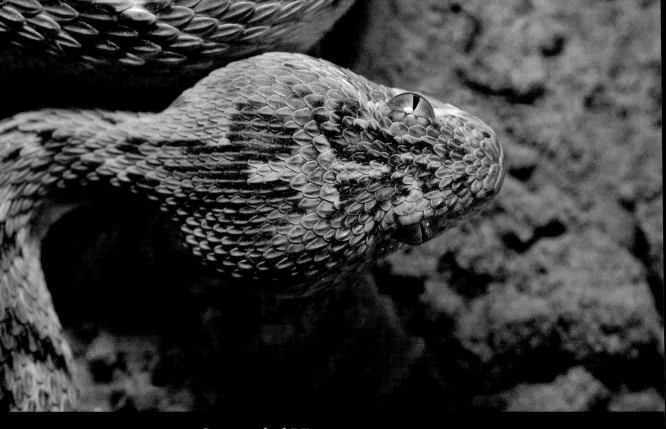

Saw-scaled Viper *Echis carinatus*

SOUTH ASIA

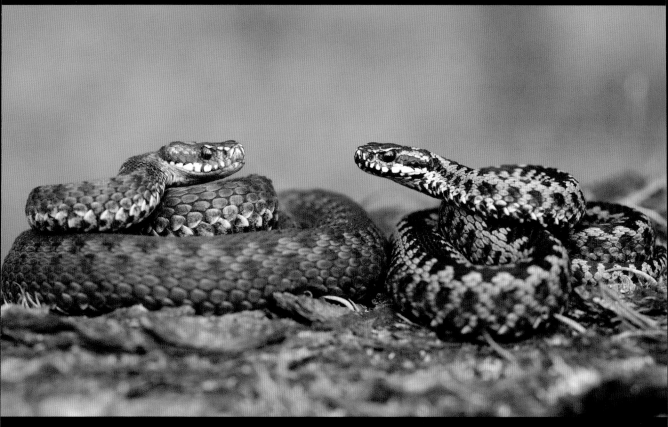

Eurasian Adder *Vipera berus*
EURASIA

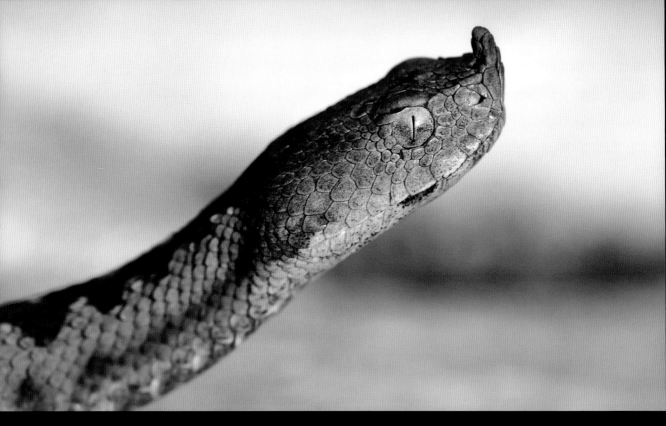

Nose-horned Viper *Vipera ammodytes*
EUROPE

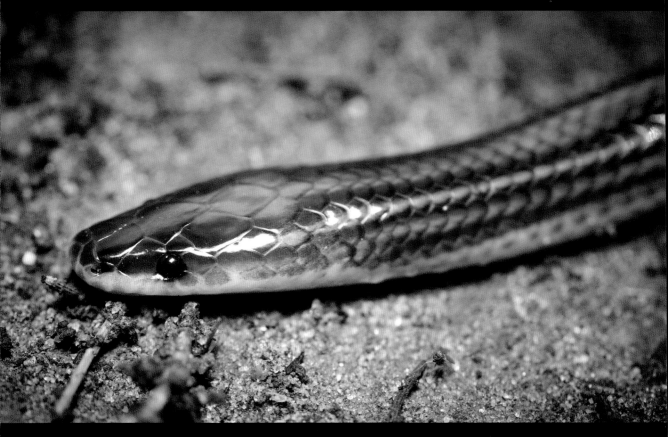

Sunbeam Snake *Xenopeltis unicolor*

SOUTH-EAST ASIA

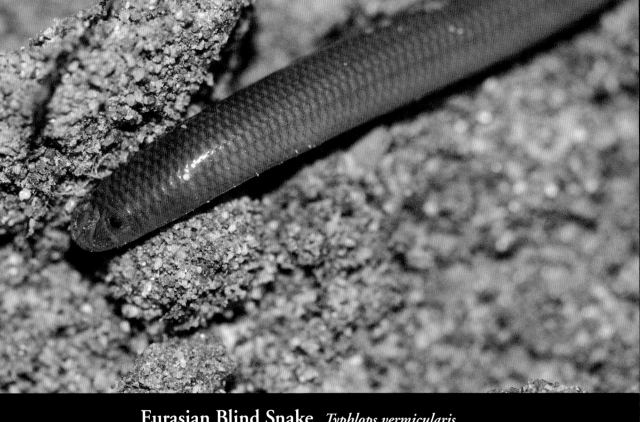

Eurasian Blind Snake *Typhlops vermicularis*
EURASIA

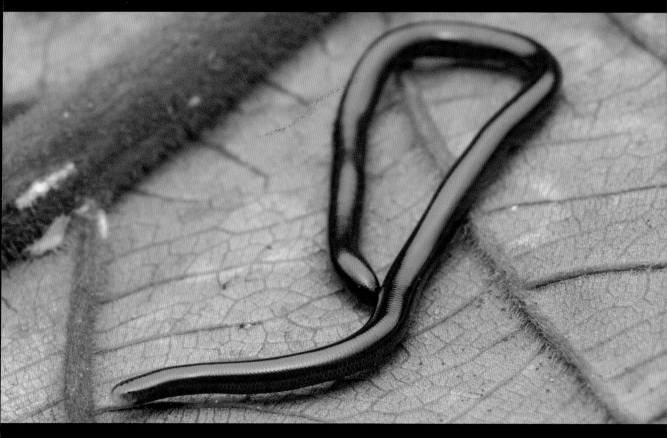

Brahminy Blind Snake *Ramphotyphlops braminus*
AFRICA AND ASIA

Blotched Blind Snake *Afrotyphlops congestus*
AFRICA

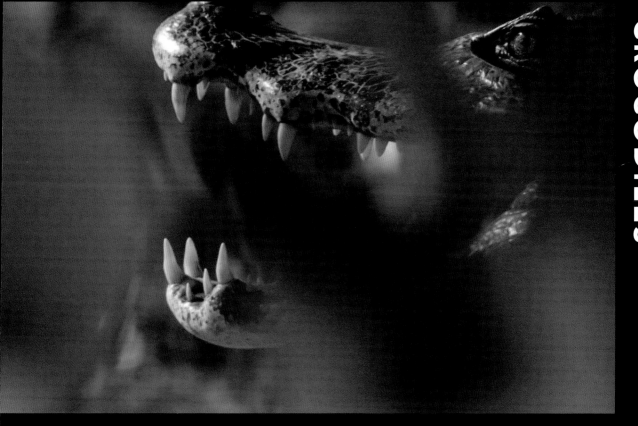

CROCODILES

Spectacled Caiman *Caiman crocodilus*
CENTRAL AMERICA AND SOUTH AMERICA

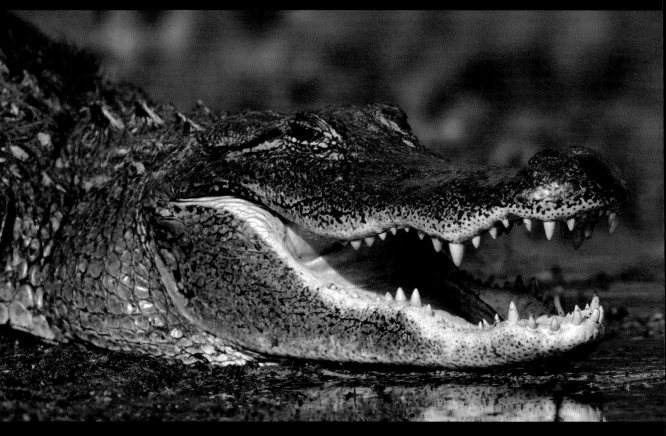

American Alligator *Alligator mississippiensis*

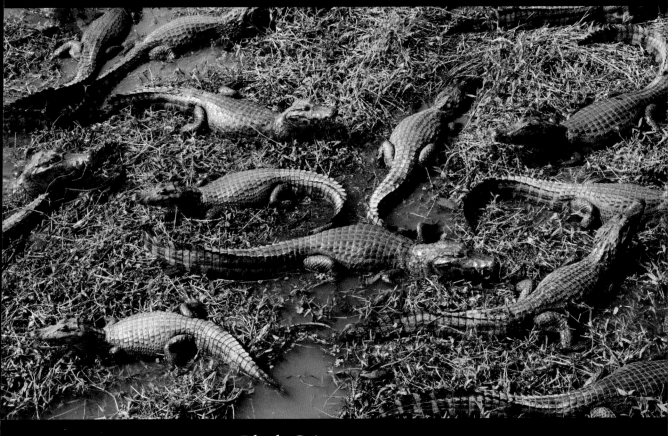

Black Caiman *Caiman niger*

SOUTH AMERICA

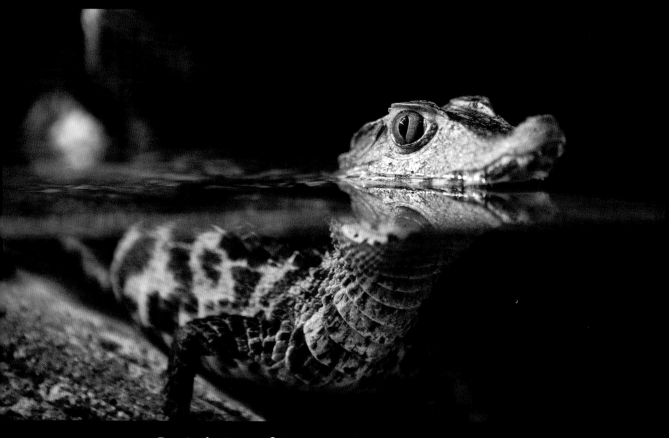

Cuvier's Dwarf Caiman *Paleosuchus palpebrosus*
SOUTH AMERICA

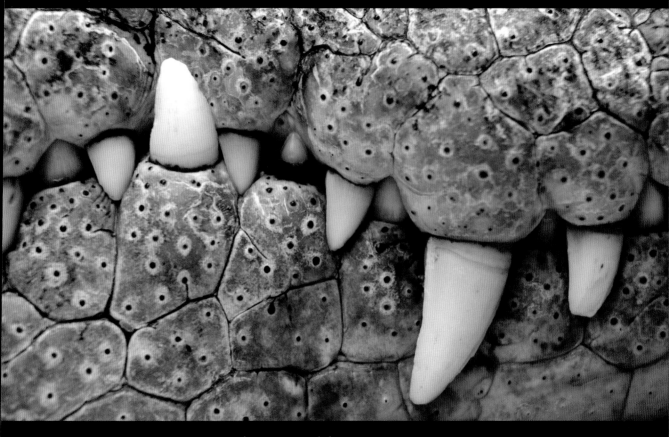

Nile Crocodile *Crocodylus niloticus*

AFRICA

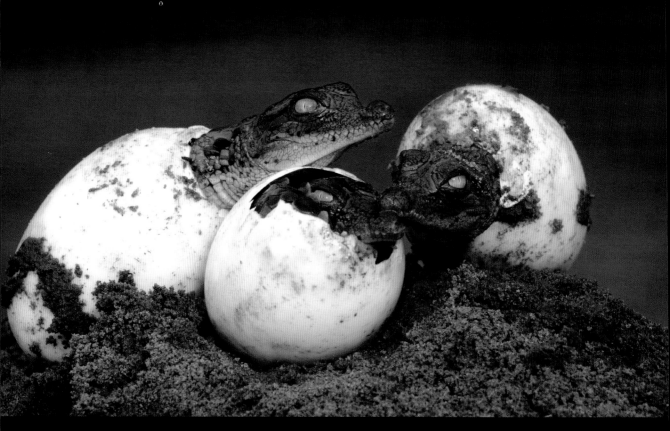

Nile Crocodile *Crocodylus niloticus*
AFRICA

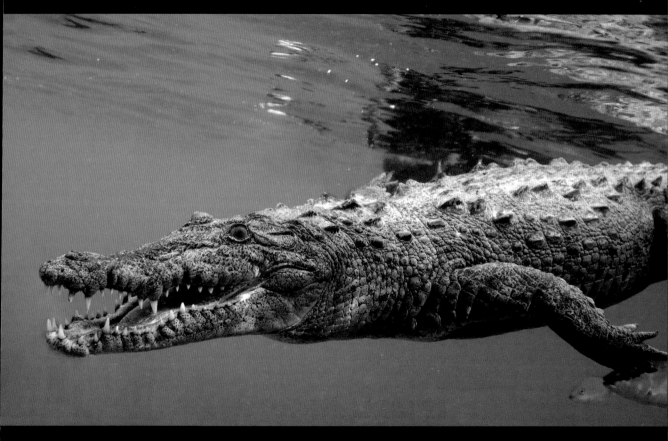

American Crocodile *Crocodylus acutus*

AMERICAS

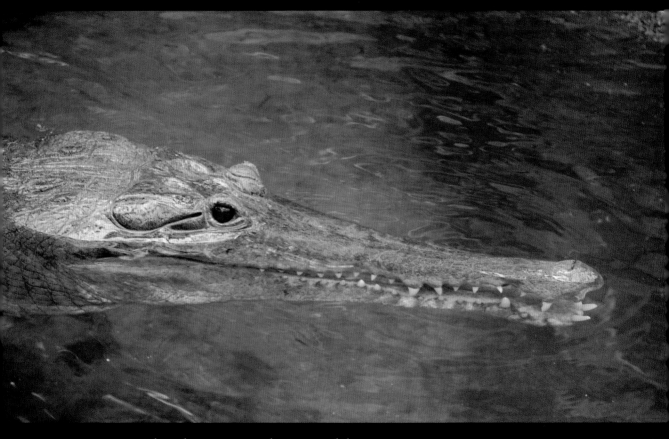

Slender-snouted Crocodile *Mecistops cataphractus*
AFRICA

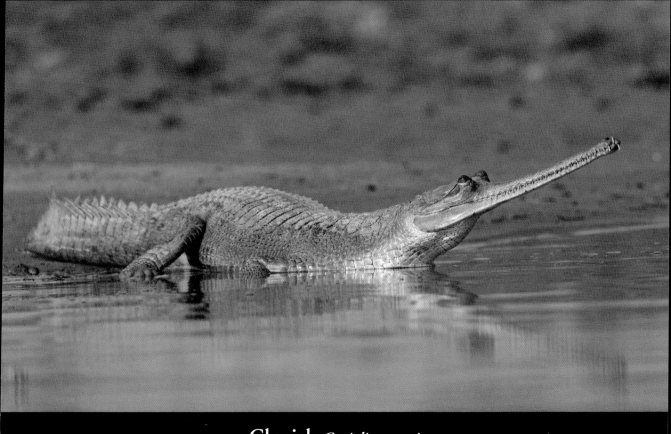

Gharial *Gavialis gangeticus*

A Complete Guide to Reptiles of Australia
Fifth Edition
Steve Wilson and Gerry Swan
ISBN 978 1 92554 602 6

A Field Guide to Reptiles of New South Wales
Third Edition
Gerry Swan, Ross Sadlier and Glenn Shea
ISBN 978 1 92554 608 8

A Field Guide to Reptiles of Queensland
Second Edition
Steve Wilson
ISBN 978 1 92151 748 8

A Year in British Wildlife
Mark Ward
ISBN 978 1 92554 611 8

Australian Wildlife On Your Doorstep
Stephanie Jackson
ISBN 978 1 92554 630 9

Crocodiles of the World
Colin Stevenson
ISBN 978 1 92554 628 6

Extreme Animals
Dominic Couzens
ISBN 978 1 92554 649 1

Reed Concise Guide: Snakes of Australia
Gerry Swan
ISBN 978 1 92151 789 1

Reed Mini Guide to Animals [of Britain]
Reptiles • Amphibians • Mammals
Marianne Taylor
ISBN 978 1 92554 624 8

World's Most Endangered
Sophie McCallum
ISBN 978 1 92554 627 9

In the same series as this title:
World of Birds
ISBN 978 1 92554 652 1

For details of these books and hundreds of other
Natural History titles see
www.newhollandpublishers.com
and follow ReedNewHolland
on Facebook and Instagram

First published in 2019 by Reed New Holland Publishers
London • Sydney • Auckland

Bentinck House, 3–8 Bolsover Street, London W1W 6AB, UK
1/66 Gibbes Street, Chatswood, NSW 2067, Australia
5/39 Woodside Avenue, Northcote, Auckland 0627, New Zealand

www.newhollandpublishers.com

A record of this book is held at the British Library and the National Library of Australia.

ISBN 978 1 92554 653 8

Group Managing Director: Fiona Schultz
Publisher and Project Editor: Simon Papps
Designer: Andrew Davies
Production Director: Arlene Gippert
Printer: Toppan Leefung Printing Limited

10 9 8 7 6 5 4 3 2 1

Keep up with Reed New Holland
and New Holland Publishers on Facebook
www.facebook.com/ReedNewHolland
www.facebook.com/NewHollandPublishers

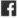

Front cover: European Green Lizard *Lacerta viridis* (Lacertidae).
Back cover: Hawksbill Turtle *Eretmochelys imbricata* (Cheloniidae).
Page 1: Crocodilian eye (Alligatoridae or Crocodylidae).
Pages 2–3: Panther Chameleon *Furcifer pardalis* (Chamaeleonidae).
Page 8: Marine Iguana *Amblyrhynchus cristatus* (Iguanidae).